Pulling a Whale

amplifypublishinggroup.com

Pulling a Whale: True Stories of Opportunity and Serendipity

For more information, please contact:
Mascot Books, an imprint of Amplify Publishing Group
620 Herndon Parkway, Suite 320
Herndon, VA 20170
info@amplifypublishing.com

Library of Congress Control Number: 2022903172

CPSIA Code: PRV0822A

ISBN-13: 978-1-63755-451-7

Printed in the United States

Remembering Bailey, Stanley, and Fredi.
Wherever I go, forever in my heart.

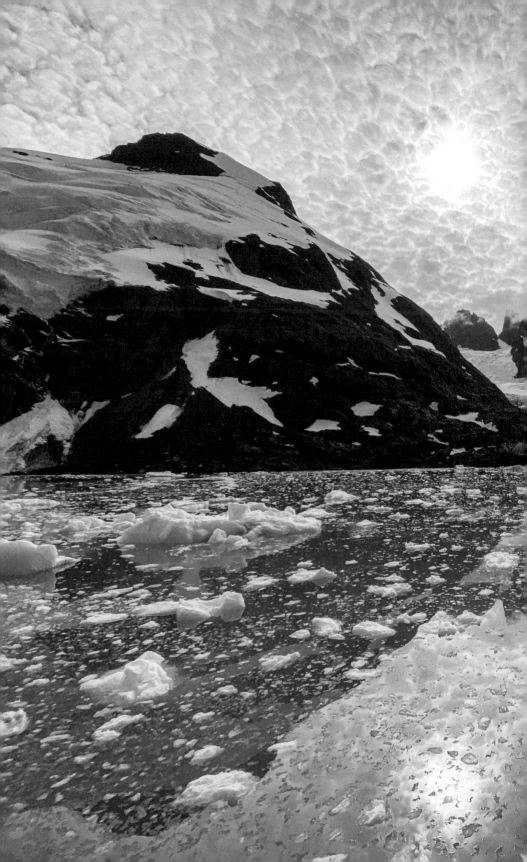

PULLING A WHALE

True Stories of Opportunity and Serendipity

DAVID BARRON

Contents

INTRODUCTION

In a Mexican restaurant, a waiter's light-hearted schmoozing leads to an Arctic helicopter ride—and the aerial view of a polar bear leaping across ice floes. A look at a poster hanging at a volunteer expo brings about travels to the beautiful waters of Mauritius—and the rare experience of swimming with sperm whales. Tracking down a classmate in Colombia elicits an offer to observe in an operating room—and photograph an unusual type of surgery.

Opportunities are always around us, in many shapes and sizes. Many we never act on, but thankfully, some we do. The stories that follow relay a few of the experiences that sprang from opportunities presented to me—and which I followed through—over the last four-plus decades. My hope is that they may just open your eyes to some of the opportunities ever present around you as well, and help you decide when you're ready to act on them.

It's not always obvious how a given opportunity might lead to something amazing. Or how it could be a life-changing move. But many times, if you decide to grab that chance, you'll find that it branches into paths that lead to surprising adventures.

Nine of the stories in this book were inspired by the two rich years I spent in Barrow, Alaska. None of them would have happened if I hadn't, as a teenager, joined a whale-tracking expedition off the coast of Cape Cod,

where I unexpectedly met five Iñupiat students—one of whom (years later) invited me to Atqasuk for a summer job dredging a pond.

Another fifteen stories arose from my work taking photographs for Earthwatch, a nonprofit that sends volunteers all over the world to help researchers studying animals and the environment.

In 1997, a seventeen-year-old volunteer named Nikolai Gurda (Niko) was working on an Earthwatch project I was scheduled to photograph in Baja. He and Jeff Seminoff, a marine biologist and turtle researcher, had encountered a manta ray that was partially entangled in their research net. Both Jeff and Niko worked hard to free the animal, but it became clear that one would have to leave the boat and get on top of the manta ray to cut away the part of the net they couldn't reach. Because Jeff had to drive the boat, Niko was asked to jump on top of the fifteen-foot-wide fish, rodeo-style, and free the last remnants of net. And somehow, amazingly, he did.

When I arrived at the project site and listened to Niko describe what had happened, there was no doubt I was jealous—I wished I could have been on that boat! But hearing him tell the story with such excitement made me feel so happy for him. This was his first big story, one that would last for a lifetime.

"Wait until you tell your classmates when school starts this fall!" I couldn't help saying. What I didn't predict was that he'd become a teacher and is now sharing this story with his students.

I still enjoy finding new adventures through opportunities that come my way. But the older I get, the more I enjoy seeing others partake in such experiences as well. Not all are as obvious as riding a manta ray, maybe, or as exciting, but most are wondrous, and unique. Many, in my

experience, come while traveling, as a kind of gift, when each waking hour offers myriad novel discoveries.

There is truly something new around each corner. And more than a few of the adventures out there, if you dare to follow them where they lead, will remain a part of your soul.

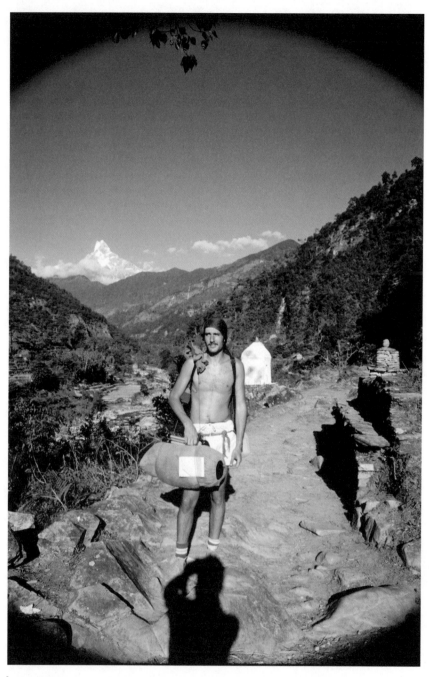

Exploring the Jomsom trek, Nepal, on a trip to Asia that would feed my lifelong wanderlust (1981 photo by Pier Steen Anderson).

THE LONG AND WINDING ROAD TO BECOMING A PHOTOGRAPHER (AND TRAVELER)

My path to finding opportunities often branched out from my work as a photographer, and from my travels. But opportunity—and the willingness to reach for it—doesn't hinge on those things. It can be found wherever you are, whatever you are doing, once your eyes are open to it.

EARLY YEARS

My dad was a dentist, and he had many hobbies. His first was airplanes and anything to do with them. His second was photography. When he took on any task, he researched everything about it and didn't hold back on any aspect of his new interest.

He started using 35mm film cameras in the early 1950s, and twenty-five years later obtained a 4 x 5 Linhoff box camera that was considered top of the line. He learned the zone system for determining film exposure and read all the technical books by Ansel Adams, perhaps the most famous landscape photographer of his time. He even took a course with the master himself at Yosemite National Park.

When I was about eight, my dad started teaching me a bit about photography and let me use his Nikon cameras. He taught me how to develop black-and-white film and how to process prints in his newly

constructed darkroom. As a child and young teenager, I put what I learned to use, taking photos on two family visits to Israel, a canoe trip along the United States/Canadian border, and a bike excursion through the Canadian Rockies.

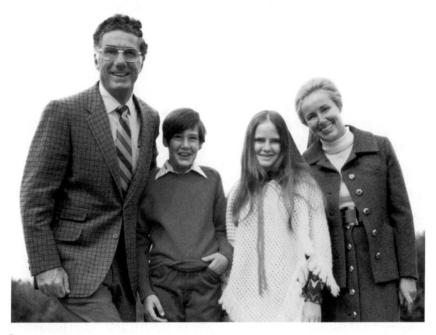

With my father, Stanley Barron; sister, Fredricka; and mother, Bailey Barron, circa 1971.

My high school, Lincoln-Sudbury Regional in Massachusetts, had a fairly liberal, forward-thinking system of education. I loved history and was exposed to history classes that were outside the norm, including Russian history, Chinese history, and Black history, which was taught by an African American teacher who came to our school just to teach that class. He would tell us about his interactions with white people as a young man, including with white policemen, and spoke of witnessing a KKK cross burning. These courses left a strong impression on me.

My school also allowed students to leave campus during the day when they didn't have classes, as long as their parents didn't object. Around my junior year I started taking advantage of this system by scheduling all my courses on Monday, Tuesday, Thursday, and Friday. Brilliant! No classes on Wednesday!

At that time my father was taking Thursdays off, having reduced his schedule from six days a week to four after a few decades in his career. But upon hearing of my "day off" on Wednesdays, he decided to change his day off from Thursday to Wednesday so we could go skiing together for as long as the ski resort was open for the season. It's one of two memories of my father doing everything he could to spend time with me as a teenager (the other was when he coached my baseball team—and he was neither a coach nor into baseball!).

During my days off in high school, as my dad and I rode up the ski lift to take our next run, Dad would talk to me about life, the future, my interests, and his take on everything.

I loved photography so much by then, and so did my dad. But surprisingly, Dad said he thought it might not be a great idea to pursue it as a profession. He told me he had met a lot of professional photographers who were all struggling financially (unless of course they were Ansel Adams). He pointed out that he and I both loved photography as a hobby, and he wondered whether it might not be as satisfying or rewarding if I followed it as a profession. Only time would tell, of course.

FIRST PUBLISHED PHOTOS

During my second semester of senior year, I applied for and was placed in an executive internship that offered course credits for working a job. My job was to take photographs for the *Bedford Minuteman* newspaper.

I would work with the editor, who wrote and edited all the stories and put the paper together . . . and when I say he put the paper together, I mean he pasted and glued printouts of the stories and photographs onto a board, which would then go to press. In those days, newspaper copy was literally cut and pasted to fill columns, which meant trimming sentences to fit into paragraphs and around photos.

In my internship position, I was primarily assigned to photography, but also some writing. As luck would have it, I found myself hitting the ground running on my first day on the job. That day there was a meeting at the high school for the student interns with the teacher who was head of the program. After the meeting, I told her I planned to head over to the *Bedford Minuteman*.

"But David, it doesn't start for a few days," she said.

"Right, but I want to get there as soon as I can," I told her.

Everybody else was going home, understandably, because they didn't have to start their jobs yet—and because there was a major snowstorm happening. Not me. I called Michael Rosenberg, *Minuteman* editor, who told me to meet him at his house. When I arrived, he came out and asked, "Do you have four-wheel drive?"

Luckily, I did (I was driving my mother's Subaru). There had been a bunch of accidents near Route 3 in Bedford, so we headed to an overpass and climbed down to the highway to take a bunch of pictures. There were a number of cars that had gone off the road, along with tow trucks, police cars, fire engines, and ambulances—just the start of the mayhem that would ensue through the night and into the next morning. I took a few more photos in the town, then headed home.

The next day I woke up to what we know now was the Great Blizzard of 1978, with snow so deep it rose above the windows of the house. In a

few days I learned that my photos had been published and were on the cover and inside pages of some five *Minuteman* papers. Nobody else had taken pictures that first day, and the editors felt that mine captured the essence of what became the storm of '78.

It was a good lesson for me—the simple decision to go in early to work might just lead to an unexpected opportunity.

CATCHING THE TRAVEL BUG

In the middle of my internship, another type of opportunity came to fruition: a trip to "Red" China. The Chinese history teacher at our school knew someone at what was only the third high school to be granted a visa by the Chinese government, Keefe Technical High School in Framingham. Keefe Tech had extra spots on their visa allowance, and without the Chinese government knowing, six of us from Lincoln-Sudbury Regional quietly joined the trip. (The visas were generally granted to "working" schools, as China's revolution was all about the proletariat.)

I knew the trip would be a rarity, since a Chinese visa was almost impossible for the average American to obtain—only the occasional business, government agency, or NGO (nongovernmental organization) staff generally succeeded in acquiring travel documents.

INTERIM YEARS—AND SOME TURNS IN THE ROAD

In 1979, when I was nineteen, my older sister and only sibling, Fredi, died suddenly and unexpectedly, at the age of twenty-two. My parents and I were left stunned. They had planned a trip to England and Israel, and they asked me if I wanted to join them should they decide to go. After giving it some thought, I realized that I'd like to meet them in Israel but stay there on my own for the summer, just as my sister had done a few years earlier.

This was a tough scenario for my parents, as they had just lost their daughter and now would not be seeing their son for the whole summer. But they decided not to share their fears or their desire for me to be around, and instead gave me a path to go on this soul-searching adventure without guilt or hesitation.

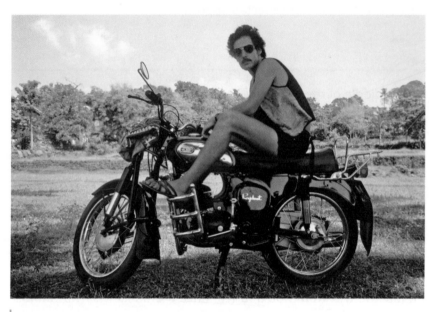

In Goa, India, on a Rajdoot motorbike touring the countryside (1981 photo by Liz).

As it turned out, my summer in Israel ended up stretching to just shy of two years. After a planned summer stay on the kibbutz Ein HaMifratz in northern Israel, the rest of my visit was unplanned—an approach I would carry into most of my travels going forward. I ended up studying at Hebrew University on Mount Scopus for a year, then traveling for almost four months before returning home from Thailand after contracting hepatitis in the mountains of Nepal.

The next few years would be a sometimes-meandering combination of study and travel. I took a few photography courses at the Art Institute of

Boston, then a few psychology courses at Framingham State University, then settled in at the University of Massachusetts in Amherst to study economics.

In the summer between my junior and senior years of college, I found myself a job way up in Barrow, Alaska, working at a wildly popular Mexican restaurant there. It was so much fun that after graduating from college, I returned to Alaska to work at the restaurant again. From there I had a series of jobs in Barrow. At the end of my second year, I had the opportunity to work on the whale census for six weeks, allowing me to see bowhead whales and polar bears. From there I started making my way home with a good friend named Bill Barber, visiting a few places on the way.

In Juneau, I met a woman named Rhonda Mann, who is a Tlingit Native American. I decided to join her driving south before catching a flight home. It was in the midst of planning this diversion when I learned that my dad had pancreatic cancer. I was in shock—my mother had to ask my cousin Saul (who years later died of the same disease) to call me and say plainly, "David, you need to get home."

I was on a plane within a few hours to see my father. But I ran away, back to Alaska a month later to take the drive with Rhonda, because I couldn't face what was happening. I called my mom each day to check in. I knew my father was not going to survive this cancer.

A week and a half into that trip, my mom told me it was time to come back, as things had started to get worse. Rhonda drove me to the closest airport, in Salt Lake City, Utah.

I flew back to Massachusetts on August 4, and my dad passed away on August 27. As I'm working on the final edit of this story, tomorrow is the anniversary of my father's passing at age sixty-one. I am presently sixty-one years old.

DECIDING TO BE A PHOTOGRAPHER

When I was twenty-seven, now living with my mom back in Sudbury, Massachusetts, I knew I had to figure out what I was going to do in life. Over the previous year in Barrow, I had thought of many possible avenues, running each new idea by my friend Stephen Newmark. Every weekend I would go to his place and work through it, only to realize that this idea wasn't the one, then the next weekend bring over another idea to hash through. I knew I wasn't making any headway and needed to get back to the Boston area before I could figure out what I wanted to do.

One day while I was in the process of trying to sell my dad's beloved 4 x 5 camera, a photographer who was a prospective buyer hemmed and hawed and finally decided not to buy it. He needed a special piece that is only sometimes included with such cameras—an extension rail for close-up work. He loved the camera and the lenses, but knew he had to find a set that included that special piece.

After telling me his decision, he said: "Don't sell it. It's an incredible camera system."

I shut the door as he left. That was it—the moment I decided to become a photographer. I figured, if I'm going to go out and compete in the world, I might as well do it with a skill I already know something about.

So I started reading a how-to book on using the 4 x 5 camera, as well as my father's books by Ansel Adams. They were very technical, but it wasn't long before I had made some images using Polaroids and sheet film.

My first gig was with Marty Goldman, a family friend who wrote for and put together the *Boston Ledger*. In no time Marty had me taking photos of political events, such as election night for the Boston mayoral and city council races. I ended up in a hotel room with incumbent mayor

Raymond Flynn and his family while they were watching the tabulations on TV. A *Boston Herald* photographer and I were the only members of the press allowed in, since we were photographers and not writers. We talked pleasantries with Mayor Flynn, took photos for a bit, and headed out.

Marty was waiting on the other side of the door as I came out.

"I can't believe you were allowed in and I wasn't!" he said. Here he was, a veteran journalist, and the greenhorn photographer was the one to get access. It was the first of many moments along the way that made me realize that being a photographer could give me entry to places I otherwise would have no business being.

Marty is the one who told me to start *calling* myself a photographer, not just say that I *wanted* to be a photographer. He said that people would take me more seriously. He was right. It also boosted my confidence to realize that I did have some skill as a photographer already.

If you had asked me when I first had dreams of being a photographer what would be so cool about it, I would have answered that I loved taking photos and seeing the final prints or slides. I never imagined that in the end it would be so much more than the images themselves—it would be the places they brought me and the experiences I would have.

PART I
BARROW, ALASKA

I first visited Barrow, Alaska—the northernmost point in the United States—in 1984, intending to stay for the length of a summer job. I ended up returning after college and living in Barrow for another two years. It was unlike any other place I'd ever been.

Dating back about fifteen hundred years, Barrow was at one time a strictly Iñupiat (Native American) village. Originally named Nuvuk, until a British explorer decided to call it Point Barrow in 1826, the town was renamed again as Utqiaġvik in 2016, long after my time there. Because I had known it as Barrow when these stories took place, that's how I refer to it here.

What made Barrow different? For one thing, the Iñupiat people have been subsistence hunters for most of their history, and when I was in Barrow many residents still got a good share of their food from hunting, despite the existence of grocery stores and restaurants. I found the culture's connection to the traditional ways intriguing—though admittedly, as an animal lover, it was hard to get used to at first.

Other aspects of the lifestyle were new to me as well. The roads weren't paved, and it was common to see snowmobiles zipping down the main thoroughfare, some trailing sleds behind if there were things to be hauled. There were no traffic lights, and no roads at all out of town—if

you wanted to leave Barrow, you had to fly. Some places I lived in had no flush toilets, and some homes required water to be delivered. Many houses had a sort of mudroom extension to the front entrance called a *cunnychuck*, which served as a barrier against the bitter cold.

The cold was different too. One time it dropped to sixty below zero—not factoring in wind chill—though the average February temperature was more like twenty below. Fortunately, it was a dry cold, so it didn't penetrate your clothing as easily. One summer I left Barrow in the high twenties (*above* zero) and flew to San Francisco, where it was in the low seventies, and I felt colder in San Francisco.

The extreme variations in sunlight definitely took some getting used to. Winter could be tough, as the sun set one day in late November and didn't appear above the horizon again until early February. As the winter progressed, it became hard to tell the difference between noon and midnight. In the summer, it was the opposite: the sun was above the horizon for two-and-a-half months continuously. When I worked at a restaurant, people would call and ask if it was 9 a.m. or 9 p.m.! In between my early and later shifts, I'd be sure to rest on the couch instead of my bed, so if I fell asleep I'd know it was still afternoon when I woke up.

The beauty of the Arctic Ocean was incredible, especially when the ice pack was visible, as it offered another layer or element that would constantly change. On my one day off each week, I would often walk along the beach looking for interesting finds, as I had done with my mom when I was young. One of my indelible memories is that of driving out toward the Naval Arctic Research Laboratory and seeing the dazzling northern lights (the aurora borealis) over the Arctic Ocean.

The town of Barrow was mostly Iñupiat, but there were a number of people from the lower forty-eight (the continental United States,

excluding Alaska and Hawaii) who lived there permanently, as well as a growing population of Filipinos who found work to help support their families back in California and elsewhere. While there was a bit of tourism, mostly in the summer, those visits generally lasted a day or two, allowing only a superficial look at the scenery. As I found during my stay in Barrow, a much longer time was needed in order to get to know the local people and understand what the culture and history of the Iñupiat are about. I'm very lucky to have had that opportunity.

Barry Akpik during my stay at his grandparents' home in Atqasuk, Alaska.

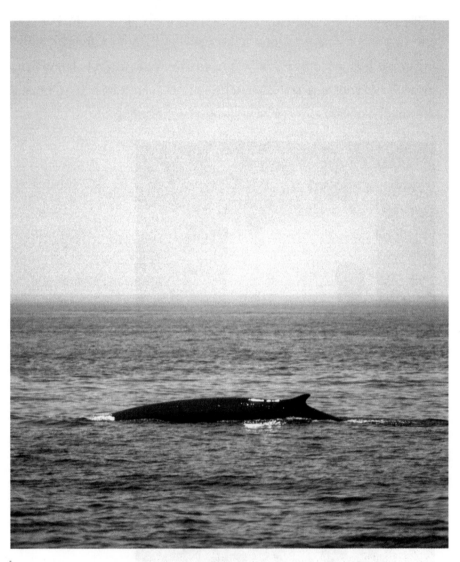

Fin whale near Stellwagen Bank, north of Provincetown, Massachusetts.

CHAPTER ONE
FROM TRACKING WHALES OFF PROVINCETOWN TO BARROW

In 1978, when I was eighteen, my cousin Betty was visiting at my parents' house. She told us that her husband, Ira, who was the head of oceanographic engineering at MIT, was in Norway working on a project mapping the ocean floor.

"That's pretty cool," I said.

"Yeah, this summer he'll be doing some whale tracking off Provincetown."

Of course my ears perked up. "That's amazing. Is there any way I could go on that trip and help out?"

Betty responded in her usual excited, positive, and encouraging voice. "Maybe! Give him a call when he gets back."

So I did, and Ira said he would let me know if it would work out to have me on the boat.

Summer came, and I got a job as a lifeguard at White Pond in Concord, Massachusetts. Then, toward the end of the summer, before I went off to college, Ira called to say that the whale tracking project was starting in two days, and that I could join them if I was available. I talked to my boss at White Pond, letting him know that I had an opportunity to track whales and needed three or four days off. Fortunately, he said it was OK.

There were a bunch of people from MIT on the project. The Edgerton boat that we were supposed to be on was in repair, so we were assigned to a different boat, which had a lot of radar equipment on it—more than even the coast guard usually has, as we found out later. One of the researchers, from the New England Aquarium, happened to be the first person to ride the orca Shamu—a killer whale—at SeaWorld in California years earlier.

Among those on the boat was a man Ira knew from Barrow, Alaska (where Ira had spent some time mapping the Arctic Ocean floor for the navy), along with some Iñupiat students he had brought down.

That night at dinner, one of the students from Alaska told us how lucky he felt to be on the trip, because he had recently been caught in a squall while hunting and had to spend the night out on the tundra. He said he had slept inside the carcass of the animal he had killed. Another student mentioned in conversation that his grandfather had just killed a polar bear.

Barry on the whale-tracking project off Provincetown.

I remember thinking to myself, "Wow, these are real 'Eskimos.'" (I know now that that's a term used by white people, and that Native Americans on the North Slope of Alaska refer to themselves as *Iñupiat*, a term similar to *Inuit*. Both terms mean "the people.")

I found out later that Ira hadn't just asked me to come on the trip because I was his cousin, it was because he knew these students coming down from

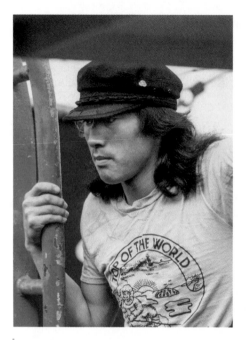
Student from Barrow aboard the boat.

Barrow were the same age as me. He understood that most Iñupiat mistrust white people, and he thought it might be easier for them to connect with me, since we were all teenagers.

After the project ended, I kept in touch with a few of the students, including Barry Akpik. We kept up a correspondence for six years or so, and this would play a part in a subsequent chapter in my life.

In the early months of 1984, Barry wrote me a postcard inviting me to come up for the summer to Barrow. So after the spring semester, I flew to Barrow and had a few hours to walk around the town before my puddle-jumper flight to Atqasuk, about sixty miles due south.

I had one anxious moment when I first approached the counters at Wiley Post-Will Rogers Memorial Airport after arriving in Barrow. When I asked to buy a ticket to Atqasuk, the agents behind the counter said they had never heard of the place. Luckily, after a lot of back and forth, one of them finally said to another agent, "Do you think he means *Atqasuk*? (His pronunciation was considerably different from mine.)

"Oh, OK, that must be it," I said sheepishly.

The agent then sent me to a hut apart from the main terminal, where I was instructed to see a guy about the flight. The guy told me to come

back in three hours, when there should be a Cessna arriving that would take me to Atqasuk.

While waiting for the flight, I decided to walk around Barrow. To my surprise, I came across a restaurant called Pepe's North of the Border. I had seen the woman who owned this place, Fran Tate, on Johnny Carson's *Tonight Show*, of all places. I headed inside and ended up speaking with her in her back office.

Once I got back to the airport I saw a Cessna take off, and thought, "That's odd." So I headed down to the hut to see the guy again.

"You missed it," he said, nonchalantly.

"But you said it was coming in first!" I blurted out.

He shrugged and said, "Oh yeah, sorry about that."

While wandering around Barrow earlier, I had met a woman who worked at the Top of the World Hotel. Not knowing what else to do, I went back to wait there, where it was at least warm in the lobby. When the woman got off work, she asked if I wanted to go with her to hang with her friends, and of course I said sure. Knowing I had no place to go, she said I could sleep on her couch, which was nice of her, given that the hotel cost over a hundred dollars per night, and I probably had a hundred dollars to my name.

At her friend's house we drank a bit, and eventually I needed to use the bathroom.

Someone said, "Oh, it's a honey bucket."

I responded, "What's a honey bucket?"

They said, "You'll see."

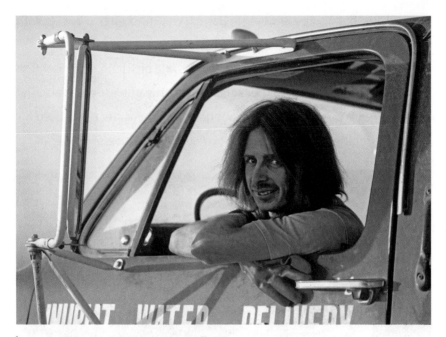

"Joe the Waterman," one of Fran Tate's sons, in Barrow.

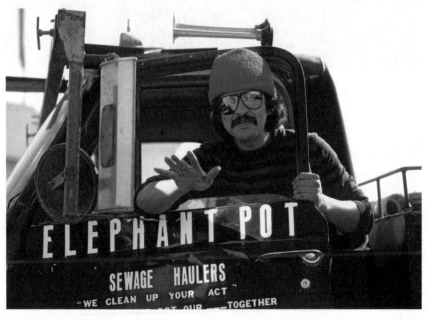

Chico Ramirez filling in for Joe on the sewage truck.

It tuned out that waste plumbing in Barrow was most often a bucket with a plastic bag under the toilet seat. When it was full it would be brought outside for the Elephant Pot Sewage guy to come pick it up. That business was owned by Fran Tate and her son Joe was "the guy." Joe was also the water guy who brought water to your house for the water tanks used for indoor plumbing, another business owned by—you guessed it—Fran.

My (left) introduction to whale meat, with Barry's cousin and grandparents.

When I finally made it to Atqasuk the following day, Barry was there to meet me at the runway. I don't remember there being any hut or building there, just a frozen airstrip. We climbed onto his eight-wheeler (I had never seen one before) and headed to the house. It was like most houses in Barrow, a small, one-story, rugged-looking home that needed paint. The wooden pallet walkway was long and would be a necessity when it got warmer and muddier. There were three caribou heads lying on the walkway, not a normal sight for me, but one I would get used to seeing that summer.

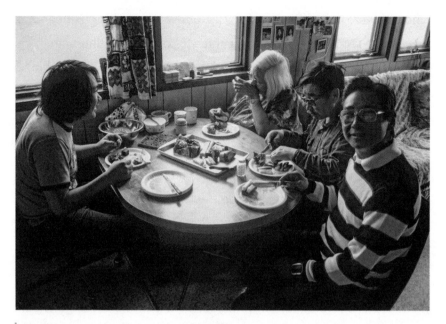

Barry (right), his cousin, and grandparents enjoying the meal.

Whale meat and muktuk.

Once we were inside, Barry quickly introduced me to his grandparents, who had raised him. I would have wanted to spend some time with them, but he rushed me to his room in the back so he could finish watching a basketball game on TV. I was surprised they could get TV reception out there, but apparently a massive satellite dish for the whole town had been put in, and the community was able to get cable.

When dinnertime arrived, I was told I was lucky, because it was whaling season and they had a treat for dinner: whale meat. When a whale is harvested, the people of Barrow divide the meat among the whole community, including the landlocked town of Atqasuk.

There were a few different parts of the whale, including the meat, the *muktuk* (skin and blubber), the liver, and so on, all on a rectangular pan. At one point someone brought out a large white container holding some fermented seal oil to go with the whale meat. I was asked if I wanted some, and I politely said no, as even from across the table I felt like I was going to be sick just from the smell.

The dredging job Barry and I were expecting to work on was on hold because the ponds were still frozen, so for a few days we mostly hung out. I started to notice that Barry was a bit unstable, and it began to make me nervous. Given that the job hadn't started yet, I decided to go back to Barrow, as I wasn't sure I'd be comfortable living at Barry's house for the summer. I was becoming aware that the town of Atqasuk was isolated and small, and staying there would make for a very different experience than living in Barrow on the Arctic Ocean, with its population of more than three thousand people.

It took three days to get back to Barrow because of bad weather, which prevented the small Cessna from making a landing in Atqasuk. When I finally got there, I stayed for a few nights with the same person I had met at the hotel, while waiting for Fran Tate to return to town.

Apparently one of the guys who had been working for Fran—the cashier, who also served breakfast in the morning—was stealing money. He was out of a job, and Fran asked me to take his place.

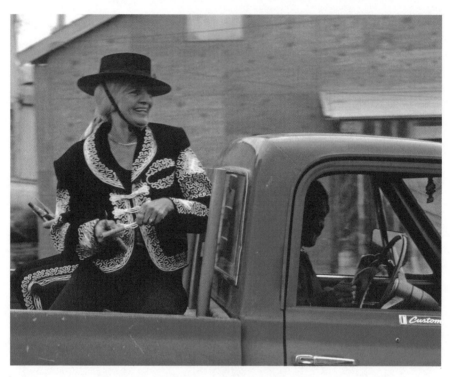

Fran Tate at Fourth of July parade, Barrow, 1984 (Perry Daniels driving).

CHAPTER TWO
WORKING FOR FRAN TATE

It was summer 1984 when I started working at Pepe's North of the Border. My job was to serve breakfast in the morning, solo, while a chef made all the meals. For lunch and dinner, I was the cashier. I was the only non-Mexican waiter. It was fascinating working at the biggest and most-loved restaurant in town.

The living quarters were tough at first, as the Mexican employees were hazing me. (We later became friends.) They'd put their speakers at my cardboard door and blast music. They knew I had to wake up each morning at 4:30 a.m., while they could sleep in until the lunch shift.

The breakfast shift was interesting—mostly the same people each day, but once in a while a new face. As part of my job, I would call over to the police station to get breakfast orders for the local prisoners, then call again when the meals were ready to be picked up.

Bob, one of the guys from the restaurant, knew one of the prisoners who was in jail for bootlegging alcohol. (The town was dry, but you could order alcohol for personal use to be shipped up on the airplanes. Some people would do that then sell it, since a thirteen-dollar bottle could sell for eighty dollars.) Bob knew this guy's breakfast order (he ordered the same thing each day) and even how many days he had left to serve on his sentence. Inspired by Bob, each day I would write a note on the Styrofoam lid of the guy's breakfast, saying something like: ☺ *Only fifty-six days to go!*

The guy was being held at the Barrow jail, but sometimes it would become too full, and they would send prisoners to larger jails or prisons in Anchorage. One day, when the orders came in, I realized that Bob's friend must have been sent out from Barrow, since his order wasn't included.

There were so many outstanding things about this job—because it was the Arctic, and it was a Native village, and the woman in charge of the restaurant was a quirky, unabashed do-it-yourselfer named Fran Tate.

Fran was a hoot of a woman, with a personality as big as they get. She was such a character that over the years she gained a reputation well beyond Alaska, with profiles in national magazines and random TV and radio appearances that earned her fans across the country. She was and will always be one of the coolest people I've ever met.

Fran was a workaholic. She was always in motion going forward, no matter what was in front of her.

I used to spend time with her in her office after my shift at the restaurant, helping her organize things and working on the list of people she owed money to, figuring out what order to pay them in. Oftentimes we'd stay pretty late at night. All her transactions would be written down on paper or cardboard, whatever she had in front of her. The next morning I'd come in early and do the breakfast shift, then go back to the office again.

Fran would typically get a phone call reminding her that a bill was overdue. She was always polite and positive and would say "OK, I'll see what I can do," or something along those lines. Then she'd hang up and tell me, "OK, David, put them at the top of the list."

Given all her years of doing business, it seemed like no one thought they would *never* get their money; it was just a matter of when. So her vendors would make their obligatory calls, while trusting Fran to be an honest and hard-working entrepreneur.

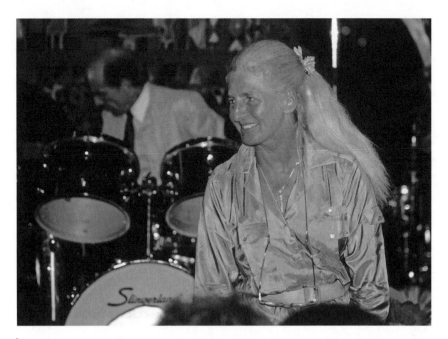

Force of nature: Fran at Pepe's North of the Border.

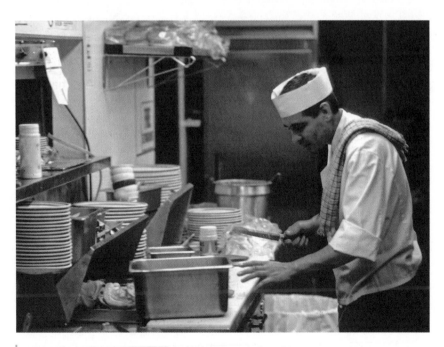

Cook preparing meals at Pepe's.

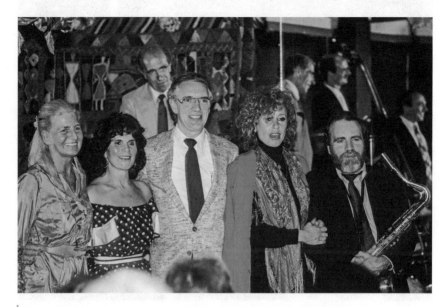

*Fran (left) at Pepe's with jazz singer Chris Calloway (in red)
and Boston Symphony Orchestra friends, 1985.*

One time she said to me: "If my mother only knew I had a Jew working
for me!" As the Jewish person in question, I was a little taken aback,
but I also knew that Fran was the most open-minded person I had ever
met. She told me that her mother had been a member of the Nazi Party,
but it was obvious that Fran had rejected her mother's anti-Semitism.

My guess is that most children who become prejudiced are brainwashed
by their parents, absorbing what they hear when they're young and
believing it, for lack of any other input. When they become adults, it's
hard to change what they think and separate it from what they've been
told. It takes a critical thinker, or someone who's willing to question, to
decide that a way of thinking is illogical. Fran was that kind of person.

Fran had a couple of dachshunds named Hansel and Gretel. She cared
about them more than probably anything. I remember one time when
Fran had painful bunionectomies on both feet simultaneously, and she

was still walking around the restaurant greeting customers. The only thing she needed help with was walking the dogs. Typically, it was her husband, Chico, who would do the honors.

There were a few occasions when Chico and Robert, a longtime employee, were busy, and Fran would ask me to take the dogs for a walk. When people who knew her found out, they'd say two things. One was: "If something happens to those dogs, you're done for." And second: "She must really trust you to ask you to walk her dogs, since that's probably the ultimate trust for Fran."

Fran and I spent a lot of time together, and we came to be good friends. Her generosity was legendary. She thought nothing of lending me her truck when my parents were visiting and wanted to see the tundra—just one of many examples. One thing Fran was not known for, however, was paying her employees as they would be paid in a typical job, where you'd get a check every week or two. In fact, Fran's employees generally didn't get a check at all until they left town. That was pretty standard for her.

Sometimes the checks would bounce, because Fran didn't always pay attention to her account balances. But she'd always make good on the payments when that happened.

During the seven weeks I worked for Fran that first summer, I survived off the tips I would get from the breakfast shift. It wasn't very busy, but I was the only waiter, and it was enough to live on. Room and board for all employees was taken care of by Fran, so all any of us needed was a bit of spending money.

By the end of the summer, Fran owed me seven thousand dollars. For a college student's summer job in 1984, that was impressive. Most kids my age would be lucky to save a thousand dollars in the same amount of time.

I remember sitting in Fran's office on my last day in Barrow that summer, telling her that my flight was leaving in an hour. She wrote out two checks, each for $3,500. Then she said, "Well, I don't have enough money in one account to cover all of this, but both of these should clear by the time you get home and deposit them."

Having spent many hours in Fran's office helping with the accounts, I wasn't so sure. I left town with two pieces of paper for my seven weeks in Barrow.

I decided to go through Vancouver, Canada, to visit a friend I had met in Israel. When I arrived back home in Massachusetts, about a week and a half after leaving Barrow, I deposited Fran's two checks. I figured the odds were fifty-fifty that one of them would clear, and I have to say I was pleasantly surprised when they both did. What were the chances?

Fran's Burger Barn restaurant, Barrow.

The next summer, after graduating from college, I went back up to Barrow to work for Fran again, as a waiter, then later as a manager of a new place she opened across from the high school called the Burger Barn. Abel,

a great guy from Mexico, came over from Pepe's as well and served as the cook. Most of the Mexicans who worked at the Burger Barn—Chico, Catarino, Adrian, Danny, Mono, Alejandro, Jose, Miguel, Abel, and Pepe—were from Guadalajara. Tom (a manager), Perry (an expeditor), and I were the only non-Mexicans to work there at the time besides Fran.

Abel Rodriguez with fresh donuts.

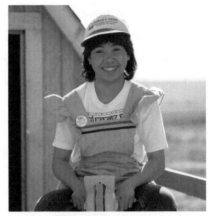

Burger Barn waitress Arlita.

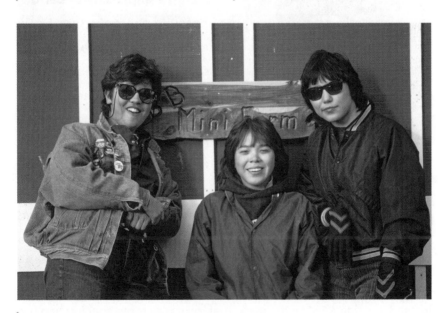

Future students of mine—Jade, Ellen, and Pukuk (Deva)—hanging at Burger Barn.

Perry was Fran's original expeditor. He'd work at Pepe's in the summers and in the winters go back to Minneapolis, Minnesota, where he made violins. I visited him at his violin workshop on one of my layovers in Minneapolis.

At one point when Perry was back in Minneapolis, Fran asked me to be her expeditor. It was a fun job—picking up items at the airport and doing all sorts of errands. Fran's truck had no reverse gear, so I had to be careful not to pull into a spot or driveway front-first. I made the mistake of doing that one time and had to ask someone to help me push the truck back out to the street.

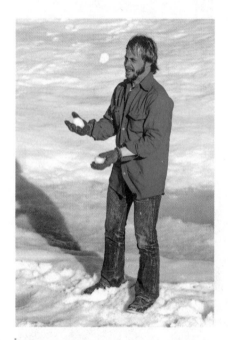

Fran's expeditor, Perry Daniels, juggling snowballs on ice pack.

Fran was always upbeat, and she would often find interesting things for us to do. One time an expedition ship (similar to a cruise ship) came to Barrow, possibly the only ship I saw during my two and a half years there. The captain and some crew members had met Fran at her restaurant, and they'd invited her to visit the ship. She didn't have a desire to go, but sent two of us in her place, and we had fun checking out the ship. I wanted to buy one of the T-shirts in the store onboard, but the store was closed while we were there, so a crew member gave me one of his shirts instead. It said *CREW* on the back, making it way more special than the one I wanted to buy.

Something that never changed was Fran's love for her dogs. One time they were sick, so she brought them down to Fairbanks to the animal hospital because Barrow didn't have a facility. She slept on the floor next to the dogs overnight so they didn't feel abandoned.

When Fran flew back to Barrow, she discovered that the airline crew had somehow forgotten to put the dogs on the plane, in the pressurized cargo area, as was always done in those days. The airline said they would send the dogs on the next plane, but Fran said no, and instead flew back to Fairbanks so she could be on the same plane as them. I guess she just wanted to see the dogs before they were put on the plane, to reassure them that everything was going to be OK.

I recently came across an article about Fran's death in 2019. I miss her and wish I could pick up the phone and say hi, as I did every once in a great while. She was truly one of a kind.

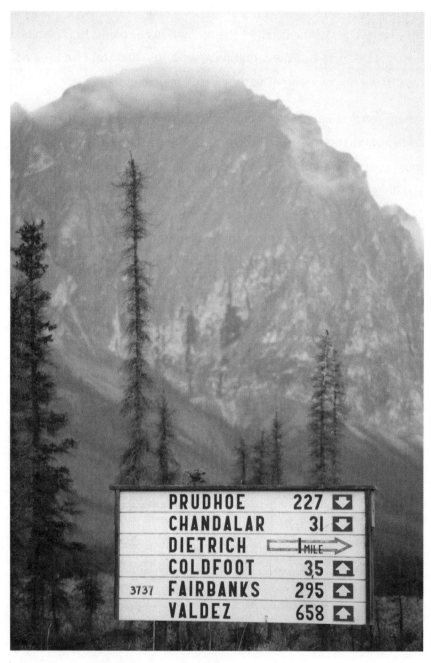

Sign on the haul road listing distances.

CHAPTER THREE

HITCHHIKING DOWN THE HAUL ROAD FROM PRUDHOE BAY TO ANCHORAGE

At the end of the summer in 1984, after working for a few months at Pepe's in Barrow, I was about to head back for my senior year at the University of Massachusetts in Amherst. I decided to take a detour to visit my girlfriend Liz Kanayurak, who was working with the North Slope Borough in Prudhoe Bay.

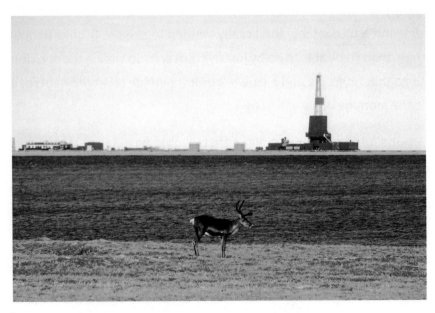

Caribou spied at Prudhoe Bay, pre-hitchhiking adventure.

Employees were allowed to have guests visit for up to three days. The first night I remember being surprised that we were served steak and lobster for dinner.

Workers for the North Slope Borough typically work twelve hours a day, seven days a week, for three weeks straight, then fly out for a week's worth of R & R. The work schedule is hard, but the pay and the meals are good enough to make up for it.

I had paid for my plane ticket from Prudhoe Bay to Anchorage, but somewhere in those three days of visiting with Liz I started wondering about a different plan: traveling down the Dalton Highway, the haul road where all the eighteen-wheelers came up and down. If it was possible to get a ride down that road, I'd be able to see the North Slope and the Brooks Range.

I was told that getting a ride would be tough—that there were maybe eight people a year who would hitchhike the haul road. It was pretty rare and a bit sketchy. But I really wanted to see the Brooks Range, more than I'd be able to do by just flying over it. So I made the decision to go that route. Liz and a co-worker dropped me off at the haul road in the morning.

Around midday I saw the plane that I would have taken, above me, heading south, and I pictured myself on it, speeding toward Anchorage. Instead, I was standing in the same place I'd been when I said good-bye to Liz. I hadn't moved more than ten feet in any direction.

By around 4 p.m., I was getting hungry. There was a warehouse nearby, and one of the workers had seen me standing on the road all day, hitchhiking without any success. He yelled over to ask if I was hungry, and was nice enough to bring me something to eat.

Finally, at about 7 p.m., a research group stopped for me. They were heading south, but planned to stay at their research site, which was north of the Brooks Range. They said I couldn't stay where they were staying, however, and that I'd have to sleep out on the tundra.

By that point I thought if I didn't get out on the road soon, I might just change my mind about this plan altogether. So I said, "OK, that's cool." We arrived at the research facility, and I headed to the open tundra.

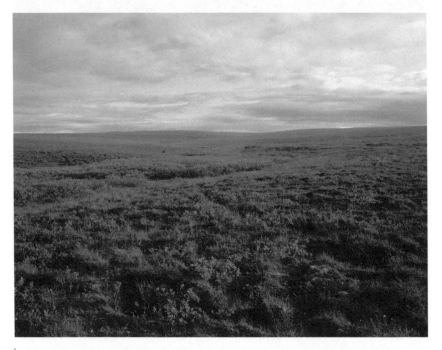

Barren tundra off the haul road—not the best place to spend a night.

It was a little chilly, and I was kind of worried about grizzly bears being in the area. I was using my jeans as a pillow, so I slipped my buck knife underneath them. I figured, "Well, if a bear comes, I'll have to defend myself." Which honestly seemed pretty stupid, and is probably why it took a while before I fell asleep. I kept thinking, "I hope I just wake up to the morning light without a bear finding me."

Small lake on tundra at dawn.

I woke up in the morning, just at twilight, and looked around. Phew! I tried not to think about the fact that I would still have been a target if a bear was nearby, moseying around looking for its next meal.

I walked over to the haul road in hopes of catching the first truck that was heading south. I had a Walkman (portable cassette player with headphones), so I stood on the side of the road listening to music. Every two or three hours I would see an eighteen-wheeler coming.

I'd see the truck from really far away, which would give me time to take my Walkman off. I didn't want anyone to get the idea that I was enjoying myself out there.

The eighteen-wheelers just passed on by. It was a bit discouraging. I definitely didn't want to spend another night on the tundra, taking my chances on a bear encounter. Luckily, sometime around midday, a guy in an Alyeska Pipeline pickup truck stopped. He asked where I was headed,

and I said, "South to Fairbanks or Anchorage." I was already climbing into the vehicle as he nodded OK.

"You slept out there last night?" he asked, shaking his head. I had to acknowledge that absurd reality.

He started chuckling, so I shrugged and said, "What grizzly bears?"

"You know, there's a family of bears that lives right in this valley— you're lucky."

"Yeah, I thought there might be some bears around."

He said he was going as far as pump station number four, which was just a little way into the Brooks Range. I didn't want to get stuck in the Brooks Range, which would be a higher elevation than the night before, and definitely colder. So he said he would drop me off before the mountains began.

"By the way," I asked, "how long *is* the Brooks Range? How many miles is it to get through? Five? Ten?"

He started chuckling again. "It's at least sixty miles on the haul road."

By the time I got dropped off, right before the mountains, it was getting to be late in the afternoon. Once again, I put my headset away as another eighteen-wheeler approached, then whizzed by. I thought, "That's probably my last chance for a ride until morning." Then, all of a sudden, the driver threw his air brakes on. "Oh my God," I thought. "He's stopping for me!" So I ran down to make sure I was the reason he stopped.

I ran back again to get my stuff. When he saw my big duffel bag he said, "Man you've got everything but the kitchen sink!"

He told me that when he saw me on the road he wondered what the heck a guy was doing out there in the middle of nowhere. He hadn't seen that before, not on the North Slope.

Marty Monsaas—the trucker who gave me a ride—stopping to check cargo.

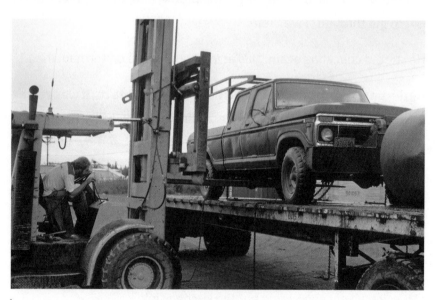

In Fairbanks, off-loading the delivery.

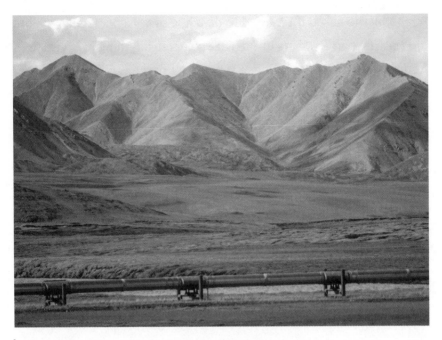

Alyeska Pipeline running alongside the Brooks Range.

Worth my time on the haul road: the Brooks Range.

After a bit, he asked if I wanted to do a line of cocaine. I declined, but did ask if he had anything to eat. I hadn't eaten anything in twenty-four hours, and I was really hungry. He said he had a half a sandwich if I wanted it, and I didn't hesitate to accept.

"I'll buy you dinner in Fairbanks," I promised him.

It was a pretty hairy ride. But it was enlightening to see how hard it was to drive under the conditions at hand. First it would be muddy, then it would be icy, then you'd be going up a very steep incline, all on an undersized road. It wasn't a normal two-lane road—you couldn't fit tractor-trailers by each other very easily.

The drivers knew the routine: before going up those steep hills, they'd call on their CB radio to direct anyone coming in the other direction to wait for them to make it up the incline before starting their way down.

The mountains were truly beautiful, and we saw some wildlife, including a lone bear crossing the road. Despite everything, it was worth making my way down from Prudhoe Bay on the haul road—a much different experience than taking the flight.

Marty Monsaas cleaning his headlight.

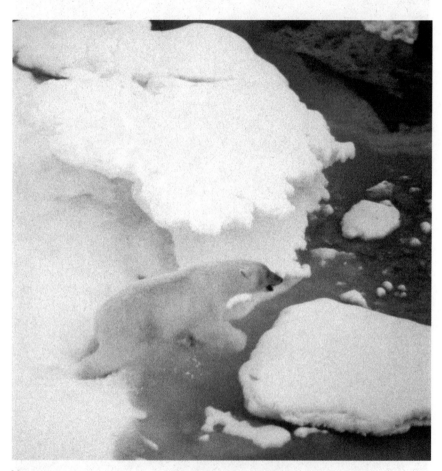

Polar bear leaping over Arctic waters, seen from our helicopter.

CHAPTER FOUR

WHEN SERVING BREAKFAST LEADS TO A HELICOPTER RIDE —AND A POLAR BEAR

It was the summer of 1985 in Alaska, and I had returned to Barrow after graduating college to work at Pepe's once again. While a lot of people working in a restaurant just serve breakfast and don't interact with customers beyond a cursory "How are you this morning?" kind of thing, I was always interested in talking to people. I've found you can usually learn from engaging people in conversation, and you never know where it might take you.

There were two guys who ate breakfast at Pepe's most mornings. They both worked for Digicon Geophysical out of Houston. Dick Madison was the lead guy, and I'm pretty sure the pilot was a guy named Joe Mackey. Their job was basically to maintain radio towers for navigation.

The towers were located on the coast and gave ships the ability to triangulate their position using the radio signals. There were no roads to the towers, so they had to use helicopters to get there.

Their helicopters would travel as far as two hundred miles down the coast at times. I asked Dick and Joe if they saw anything cool along the way, and they said they'd seen a lot of grizzly bears on the southern reaches of their trips. I said, "That's amazing! If you ever can take another

person along, I'd love to photograph them." They told me they were not allowed to take anyone on these flights.

Day after day we would talk about life, until one day, after maybe a month, they said, "Maybe we'll take you to see the bears. We'll let you know, and you'll have to be ready to go. It's going to be a one-shot deal. If the company were to find out, we would lose our jobs."

A week later they said: "Tomorrow's the day."

I went to Fran and explained the situation. She said, "No problem, we can cover for you." She knew it was a great opportunity for me and was very supportive.

The next day, Dick, Joe, and I boarded the helicopter and began to fly west along the coast. I was so excited about seeing some grizzly bears. But then it started to snow.

Readying the helicopter: Joe Mackey (left) and Dick Madison.

PULLING A WHALE

We had run into a squall, and possibly a storm front. So we landed at the village of Wainwright, eighty-five miles from Barrow.

I knew this was a one-shot deal, and that they weren't going to take me twice. They decided to refuel and see if the weather would turn, but it just got worse. "Sorry, we have to turn back to Barrow," they said. We began flying back along the cliffs of the coastline, which were about sixty to a hundred feet high in places.

Dick (left) and Joe fueling up.

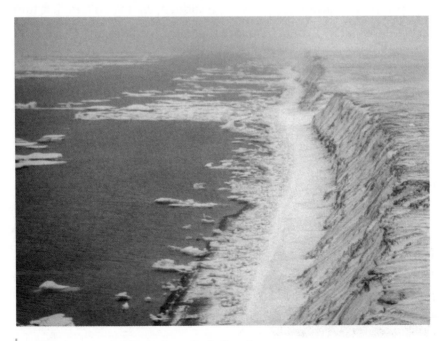

Cliffs along Arctic Ocean, from the helicopter.

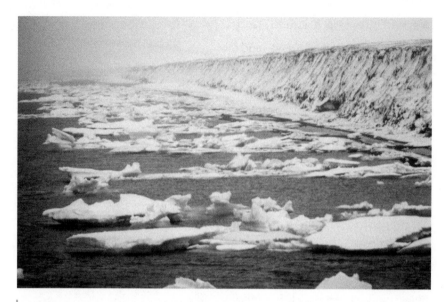

Ice on the Arctic, from above.

I was feeling disappointed about losing my only chance to see some bears from a helicopter when all of a sudden, we took a hard left turn toward the pack ice, and the pilot called out: "Polar bear!"

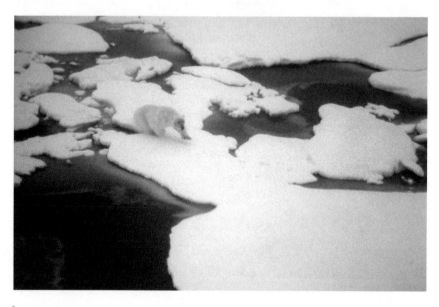

"Polar bear!" Running on pack ice.

I had my camera ready. The pilot flew around the bear as it was running, while I kept taking photos. I made sure the shutter speed was fast enough to stop the motion, since both the helicopter and the polar bear were moving.

We circled the bear twice. The bear was running on an ice floe, and when it got to the edge, it leaped over to another ice floe. It was amazing. I was so happy! It was my first polar bear sighting, and it was actually better than seeing grizzlies. I have loved polar bears since I was a kid. I still remember my mom helping me make a batik image of a polar bear when I was young.

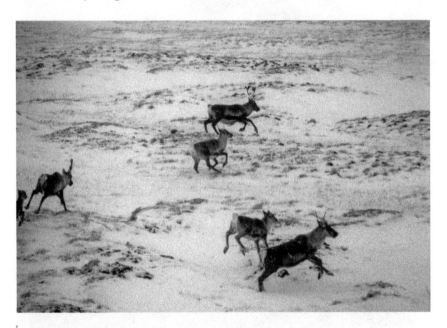

Caribou on the Arctic tundra, spotted from above.

Sometimes serving some guys eggs, toast, and coffee while shooting the breeze might just lead to seeing something as cool as a polar bear leaping from ice floe to ice floe—from a helicopter.

*Bundled in wolf-and-wolverine parka over beaver hat,
with .30-06 rifle slung over my shoulder.*

CHAPTER FIVE
HUNTING CARIBOU AT 27 BELOW ZERO

When I went to Alaska, I knew that hunting had been part of Iñupiat culture for hundreds if not thousands of years. I have always been interested in learning about and experiencing other cultures, and that means not to judge based on my own culture, but to see how and why others do what they do.

As a person who loves the natural world, especially animals, I can understand how it might be hard for some to fathom the taking of an animal's life. The fact is, if I looked through Iñupiat eyes at how my own culture secures and raises our food—food that we eat from afar—I would have some serious reservations.

When most people go food shopping in the lower forty-eight (where I grew up), they just look for meat in the meat section. It isn't labeled "cow" or "pig" or "sheep"; it's referred to as steak or burgers, pork, or lamb. When that piece of meat is bought, the person at the meat counter simply replaces it with another one.

We all know our meat comes from an animal, but the concept is a bit abstract and removed from the reality of how a living animal gets to a person's dinner plate. I believe that if most people visited a slaughterhouse, a large percentage would consider becoming a vegetarian.

At the same time, so many people don't finish the food they're served, and it often gets thrown out. Imagine that an animal is raised to be slaughtered, just so people could eat it. Now imagine tossing part of that animal simply because someone has overfilled their plate. I suspect that if people had to hunt for their own dinner, they would think twice before throwing out half of that hamburger or steak.

In any case, in 1986 I was living in Barrow, and I decided that I wanted to go hunting. I wanted to understand what it took for the Iñupiat to survive in such a harsh climate, and I knew that one of the things you had to do was hunt for your food.

My friend Jose and I decided to go caribou hunting on our next day off from work, regardless of what the weather was. As it turns out, it was -27 degrees, and the wind chill was -80. A temperature of 27 below is cold enough, but when you're out in the tundra and the wind is blowing, it stings wherever you have an uncovered part of your body facing the wind.

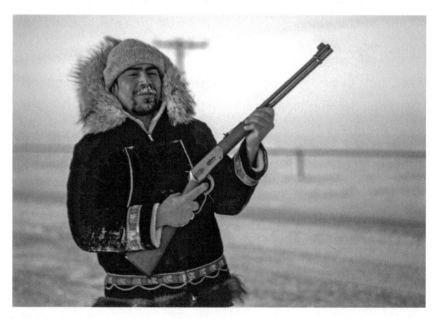

Jose with hunting rifle.

PULLING A WHALE

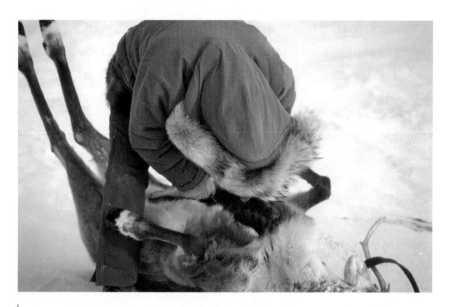

Jose gutting caribou on frigid tundra.

After being out for a while, I shot a caribou from pretty far away. I knew that I had hit it, and that it was down. So I went over to the animal, only to find out it was still alive.

By then my gun had frozen. I had no choice but to use my knife to kill the creature, so it wouldn't suffer. It was one of the hardest things I've ever had to do.

I was pleading with the animal to die, because I felt so bad it was suffering. The reality is that the caribou died so that I could eat it. I reasoned that it was the same thing that happens with a cow. I guess the only difference is that a cow suffers most of its life, because it is raised just to be killed—cooped up or fenced in and fed foods to fatten it for the ultimate goal of being slaughtered and offered for sale in the meat department of a supermarket.

At least, as I reasoned, the caribou is free on the tundra for its entire existence, until a hunter like me ends its life. It might be a harsher life,

but to me it felt like one that was more in keeping with nature. I guess if I were an animal, and I had to choose between being raised in captivity for slaughter or living in the wild and being hunted, I would choose to live in the wild.

One thing was certain: after killing this caribou, I was determined to make grateful use of every piece of the animal that I could.

First, I gutted it and removed the parts that humans don't eat (although animals on the tundra would eat almost all of it). I would be sure to eat or share every bit of meat and let none go to waste.

When I got back to Barrow, I cured the hide to make mittens from it and use the rest for a sleeping mat.

Mittens I sewed from caribou hide (inset shows caribou fur inside).

A few women taught a sewing class at the high school on weekends, so I decided to bring along the caribou mittens I was working on. The women couldn't believe it. "Oh! I haven't seen that in a long time," they said. I was told that very few people made mittens from caribou anymore, because it was easier to make them from mouton (sheepskin), which is more pliable and much softer. But in the old days the Iñupiat made most of their clothing from caribou or seal skins.

I didn't stop there: I made a key chain from the hoof of the caribou. The legs went to people that had dog teams, to feed the dogs.

I was even able to find someone who could use the head of the animal. A woman I worked with at the North Slope Borough liked to make caribou head soup. She had mentioned it to me after I told her that I had killed a caribou, so I said I would bring it in for her. But not before a moment of levity. There was a guy in the office that I had become good friends with, though every day he would snoop around in my drawer to see what I had brought in for lunch. It kind of annoyed me, so I thought, "OK, I'm going to get him."

I wrapped the frozen caribou head in a large brown lunch bag, brought it in to work, and put it in my drawer. Like clockwork, the guy came over and started snooping around. He found the bag and was opening it as I began chastising him. Then he jumped back and cried out, "What the hell!"

Needless to say, that was the last time he went looking to see what I had for lunch.

With my mission accomplished, I delivered the caribou head to the woman in the office who wished to use it. Since the animal had died so I could eat it and learn about the survival of the Iñupiat, there was no way I was going to waste any part of it.

Iñupiut-crafted skin boat, with ice blocks arranged to camouflage from whales.

CHAPTER SIX
PULLING A WHALE IN THE ARCTIC

It was 1986 in Barrow, and I was working as a teacher's aide/teacher at Barrow High School. I had recently bought a snow machine (commonly called a snowmobile) from a student who was heading to the lower forty-eight after graduation.

I bought it so I could go out and photograph the harvesting of a whale after whaling season started, because I needed to get to the site early to see and document the process. Without my own snow machine, it would be unlikely, since most people head to the harvest a few hours later, when they're needed to help pull the whale onto the old ice.

The snow machine I bought was a Yamaha 340, and it could zip along. Its windshield was cracked, the previous owner's dog had ripped apart the seat, the skis needed new parts, and the treads needed some work. The brakes didn't work either. And the machine didn't start unless I poured some gas into the carburetor.

But I bought a new windshield and parts and found a seat in a dumpster at the high school, and eventually had a friend install a primer that sent gas straight to the carburetor to prime the engine for starting. Now my hands didn't smell like gasoline everywhere I drove the machine.

The brakes were a different story. Those would take a year to fix. In the meantime, I learned how to come to a stop by sliding sideways to slow down the machine. I became adept at judging when to start the slide before I ending up crashing into oncoming vehicles at some cross street.

Did I mention that the headlight didn't work, so at night I could see everyone else, but they couldn't see me?

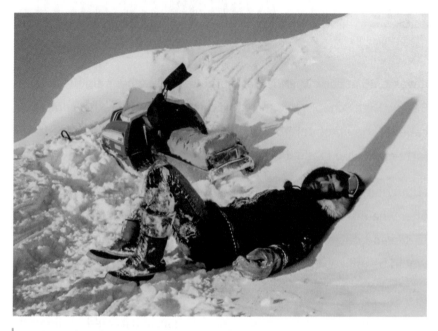

My legendary first ride on a Yamaha 340 exciter.

One night I was making my way back from Stuaqpak (the supermarket) when I saw a snow machine with three people on it speeding across someone's property, about to cross the road. They clearly didn't see me. In a split second I had to make a choice: slowing down meant I would probably hit them (and there was a telephone pole where we would intersect), while speeding up meant that neither of us would hit the telephone pole, but they would glance off me. So I chose to gun it.

The other snow machine hit the back of my machine and turned over in the snowfield. I ended up off the road, speeding toward the side of a house. There was yellow caution tape around the house, and signs warning against driving across the property.

I knew if I hit the house, someone might come out and possibly take a shot at me. So I jumped off the machine and hoped it would miss, but the machine tapped the house just enough for someone inside to hear. I pulled the machine away and started to make my getaway as I called to the other folks to ask if they were alright.

I heard someone say, "David?"

"Yeah?"

The kids in the other snow machine were three high school students of mine. They said they hadn't seen me.

"Yup, I have no headlight," I confessed. "But you guys should be careful when crossing the road."

I pointed out that I had just hit the house and said it might be a good idea for us all to take off before someone came out.

"See you tomorrow at school," I added, brightly.

Spring came, and whaling season was upon us. I had taken my trusty snow machine to the house of my friends Linda Plattner and Tom Bowers, along with my slide projector so I could show them photos I had taken of them running their dog teams.

After we started the slideshow, a call came over the CB radio from one of the whaling teams (I believe it was Amogak's team). They had caught a whale! The team was proud and excited because only nine strikes were allowed for that year.

Every year, the North Slope Borough would conduct a whale census to determine the health of the region's bowhead whale population. The

Iñupiat villages worked with the International Whaling Commission [IWC] to set the number of strikes allowed that year, in accordance with the whale census.

Whenever a whaling camp announced a strike, people in the town generally waited a few hours, then headed out to help pull the whale onto the ice pack. It usually takes a while for the hunters to get the whale to the point where they can haul it in.

I explained to Linda and Tom how to advance the slides and left quickly to get to the whaling camp to take photos.

First, I went home to get all my gear, then proceeded out onto the Arctic Ocean. Not really knowing which direction to go, I was hoping to run into someone on the ice pack. Luckily, I came across some passing snow machines and asked one driver which way I should head to find the whaling team that just caught a whale.

In about half an hour I found the whaling crew. When I approached, I saw eight people dressed in traditional white hunting jackets with animal fur around the hoods. I noticed they were making holes in the ice, then threading rope through from one hole to another to pull the whale along under the ice. It was a beautiful, pristine scene on the ice pack, and I felt honored to witness a traditional way of life.

The team was working together, not saying much, as they all knew their jobs. This whaling crew had been hanging out at the whaling camp possibly for weeks, waiting for the right opportunity to hunt a whale, and now was a time to be proud of their hard work and their achievement. The whole village would be coming out to their camp in a few hours to recognize their success and help pull in the whale and share the harvest.

I took out my camera and started taking some photos. But all I could think was, "This is cool, but I wish I could work with them."

Iñupiats pulling bowhead whale under new ice.

Cutting holes for rope to pull whale.

After a minute or two, one of the guys called over to me. "Hey, when are you going to put that camera down and help us?"

"I thought you'd never ask."

I quickly headed over to help, thrilled that at least one of the crew felt comfortable enough to ask a non-Native guy to partake in this ancient yet ever-present ritual.

More hole-cutting underway.

The group elder was the one making decisions about where to put holes for the next rope, and the rest followed. We were on first-year sea ice (ice that does not survive the spring and summer months). It was smooth and thin, probably no more than eight to twelve inches thick. The crew was moving the whale toward the older ice, because it was thicker and could support the whale's weight.

I worked with the youngest guy, who was around my age. Our job was to pull the whale under the first-year sea ice. At the edge of the old ice, the team had made a rectangular hole, which is where they would pull the whale through to get it onto the old ice.

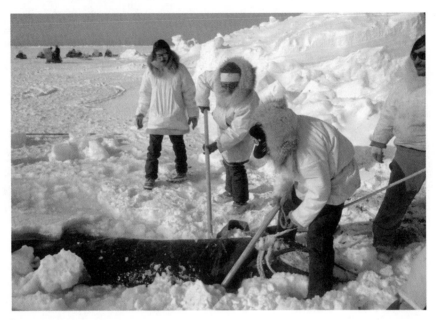

Securing block and tackle to bowhead whale.

So there I was with this kid, each of us leaning forward, pulling a rope with a whale on the other end. The kid was showing me what to do by example. At some point, because of the slightest motion of the Arctic waters pushing on the whale just below the ice we were standing on, we were able to walk the whale ever so slowly to the next spot, where the rest of the team had already threaded new holes in a long line of holes toward the old ice. Keep in mind that an adult bowhead whale can weigh 120,000 pounds (60 tons) or more.

It was probably the craziest, coolest, most interesting thing I had ever done.

Waiting at whaling camp.

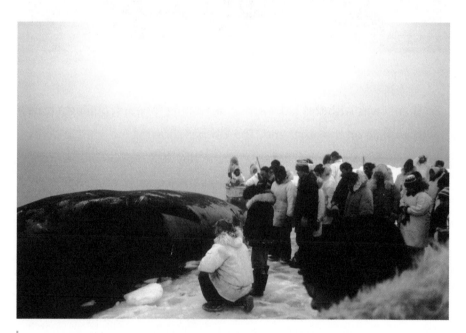

Praying to the whale, in thanks for giving its life to help sustain them.

The community members would arrive to help pull the whale through the hole using block and tackle (two or more pulleys with a rope or cable threaded between them to move heavy loads). Then they'd proceed to harvest the whale. Everyone in the community would bring some home with them. Of course, the whaling captain's family would be allotted many of the prized parts of the whale.

Making the decision to move to Barrow, Alaska, had brought me to that point. And buying the snow machine, as imperfect as it was, had given me the freedom to get to a whaling harvest early. All the choices I had made had led to an opportunity to see something I had never seen before, and to participate in something I had not considered a possibility. I had figured I would be lucky to get some good pictures. I had no idea I'd be asked to help pull a bowhead whale.

To be able to participate intimately in someone else's culture, especially a culture so different from my own, was an amazing feeling. As much as I loved animals—and I grew up watching Jacques Cousteau—I had learned the importance of subsistence whale hunting from actually living in Barrow. As part of my life there I developed an understanding of the Iñupiats' connection to their world and their ancestors.

As I write this now, thirty-five years later, it is very likely that the young man I was working with in pulling that whale is now a whaling captain. Maybe he has a son or a nephew of his own who is part of the next generation to pull the whale.

Arctic moon in season of twenty-four-hour darkness.

CHAPTER SEVEN
LAND OR ICE?

It was the winter of 1986, and I was at a party in Barrow late on a Sunday night, having a conversation with a guy named Mike Aamodt. Mike was married to an Iñupiat woman, Patsy, and he was at that time an assembly member of the North Slope Borough, the seat of government for the northern part of Alaska, encompassing around 94,000 square miles. Mike was the first non-Native American to be elected to the assembly.

As we talked, he told me he was a fox trapper. Fox are hunted for meat and pelts as a part of Iñupiat culture. The fur is used for clothing to keep out the cold. I was curious about what the process entailed, and I asked Mike if he would ever consider having me along. Mike told me he was actually planning to head out to check the traps in about five hours, so if I wanted to go with him, I'd have to be at his house at 4:30 a.m.

Since we would be out on the tundra, where there weren't any phones, I quickly went to Kathy Copa, the head of the office at Barrow High School (who was at the same party) to "pre-arrange" my calling in sick to my teaching job there. After covering for my job, I scooted out the door so I could catch a bit of shuteye for the morning's adventure.

At the prearranged time, I arrived at Mike's house, where he was getting his gear loaded onto a sled.

"I didn't think you would actually show up. I'm impressed," he said. Mike had told me to dress warmly, and I did the best I could, but after looking down at my feet he told me he had a better pair of boots for me to wear.

We headed out, each on our own snow machine, in an eastern direction from Barrow (as far as I could tell). Once we were out of town, the landscape seemed surreal. The moonlight was enough to light the land as we rode our snow machines at a steady pace. The land, of course, was all white, covered in snow and ice.

The sky was dark except for the moon, which was not unusual, as it had been continuously dark for almost a month by then and would stay that way until early February. It was my second winter in Barrow, and I knew very well the cabin fever that could be experienced during these months, as well as the strangeness of continuous sunlight in the summer.

As we rode my thoughts would wander, from making sure I was going the same relative speed as Mike to noticing what it felt like to be riding out on the tundra at that hour and imagining how I would describe it to my friends and family back in Boston. It was like being in the middle of a living Christmas scene, with Santa Claus cruising along behind his reindeer (better known in these parts as *caribou*). But caribou would have been quieter than our snow machines.

We stopped to have some hot chocolate to warm up. When I got off my snow machine, I felt something on my cheek and forehead and realized it was ice, so I pulled it off so I didn't get frostbitten. I needed to warm up my hands, so Mike lifted the cowling and told me to put my hands next to the engine, which did the job.

Hand-warming-by-engine was lesson number two, the first being make-sure-to-wear-warmer-boots. Today I was the student, not the teacher.

The next time we stopped, Mike asked me if I knew where we were, on the mainland or on the ice pack. I said I thought we were on land, only to find out we were about five miles offshore on the ice pack. I was

surprised—it was hard to differentiate between the two on the surface, as everything was white.

I realized I would have to pay more attention to the details and the direction of travel. In northern Alaska, not knowing where you are, or whether you're on land or the ice pack, can lead to a dangerous situation if you get stuck, or if some situation arose that you had to get out of. Lesson number three had been learned, and it was only 8 a.m.!

We came to a break in the ice, where there was a small section of water that we had to get across. Mike explained that we would have to find the shortest point and jump the snow machines from one side to the other.

"You'll have to push the sled when I say," Mike told me as he started for the natural ramp. "OK, OK, now!" I started to push the sled, but I was way too late. The snow machine was halted suddenly by the rope between it and the sled, throwing Mike off into the snow.

Mike was a bit banged up and not happy, and I was really embarrassed. He got over it quickly, but it took me longer, as I really didn't want to disappoint him after he had been nice enough to bring me along in the first place. What Mike had wanted me to do was to start pushing right away, then increase the speed of the sled as soon as he said "now!" Lesson number four had come at a price: embarrassment.

When we got to our destination, we checked a few fox traps, then headed to the hut. We tried to warm up a bit, but there was no heat in the cabin. We did have some frozen raw caribou, which Mike cut into thin slices.

After Mike went to look at some more traps (leaving me in the cabin, as it was even colder outside, and I was freezing) we headed back to Barrow.

I was thinking how fortunate I was to have met and talked to Mike at the party the night before, and to be invited along. Each adventure opens a door to new knowledge, and this was no exception.

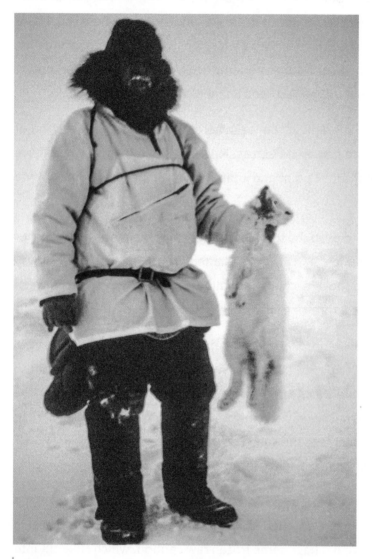

Fox trapper Mike Aamodt. Taken by moonlight with a very long exposure!

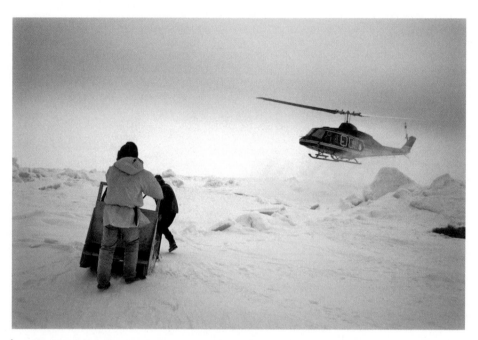

North Slope Borough rescue helicopter landing.

CHAPTER EIGHT
FLOATING OUT TO SEA

In 1987, at the end of my time in Barrow, I had the opportunity to work on a whale census for the North Slope Borough, a project that promised to be a great finish to my stay there. When I arrived on the project, Craig George told me I was the first person to show up with his own snow machine and his own sled. My sled, which I'd bought not long before, had been made by one of the students in shop class at Barrow High School.

I recorded what happened over the next few days in a journal, and I think drawing from those notes may be the best way to relay what happened next.

Thursday, April 23. The team moved everything we needed via sleds from the Animal Research Facility (ARF) at the Naval Arctic Research Lab (NARL) and set up camp on the ice pack. The bowhead whales would be traveling through the open lead, which happens when the ice first starts to break up in the spring, leaving paths for the whales to travel through. In order to breathe, the whales needed just enough area to surface so they could exhale and inhale.

Sunday, April 26. Geoff Carroll and Dave Ramey, two members of the crew, had seen a mother polar bear with two cubs, so I got out of bed to photograph them. The mother was leading her cubs around our camp. The cubs were not more than a few weeks old and about a foot to a foot-and-a-half long. The mother would turn around every so often and lumber back to prod the cubs to move faster. The cubs were playing at one point, vying for the upper position in the sibling rank. They were adorable.

I took some photos from a raised mound of ice and then some video. As I closed the video case by snapping some clips into place, the sound was a bit loud, and the sow (the mother) quickly ran to her cubs and stood in front of them, looking at me in defiance. I realized then that I was too close—that the distance she had just run was about the same length as that between her and me. Bears can run pretty fast when they need to, so I was lucky she ran toward the cubs and not in my direction.

Someone on the crew noticed what was going on and told me I should move back. I didn't hesitate to agree, since I didn't have a shotgun with me. We carried shotguns for protection, because the polar bears didn't have much fear of humans, but the last thing we wanted to do was kill one, so we tried to stay far enough away when we saw them.

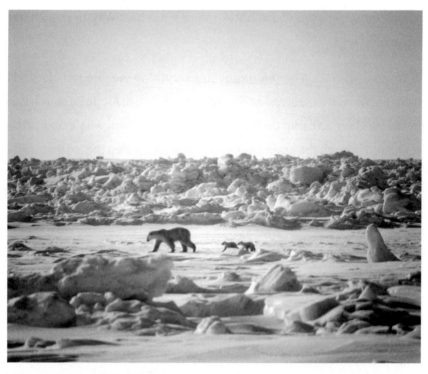

Unexpected sighting: polar bear mother with her two cubs.

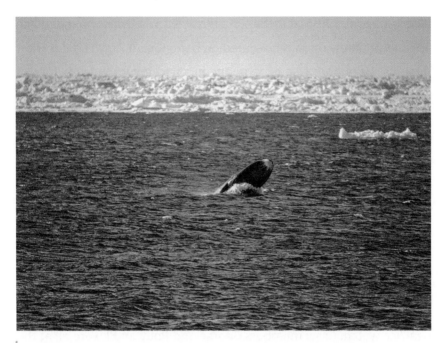

Bowhead whale spotted breaching during our survey. It's thought that the whales like to breach repeatedly during windy conditions.

Polar bear on the ice pack sensing our presence.

Wednesday, April 29. I sat in the sun a bit, as the wind was minimal, while Jo, another crew member, worked on her igloo. At night I did a short bear/ice check from 10 p.m. to midnight, checking for the proximity of bears and monitoring the condition of the ice. Since the wind had picked up, I went out on a snow machine looking for cracks in the ice pack. I saw only one crack that looked suspicious and marked it with a flag and some snow script, then told Geoff about it on my return to camp.

Thursday, April 30. We were supposed to start our first census watch in the morning, but the ice had moved in, so I went back to sleep. No whale would be coming through until the lead opened up. I got up around noon to find that the ice was still pretty bad.

Geoff went to sleep at that point, since he had the midnight-to-4 a.m. bear/ice watch. Crew members George and Polly and I were all at the perch—a place on top of a pressure ridge (where ice buckles up from lateral pressure of the wind or tide). It's there that we'd set up a theodolite to collect data on the location and travel of the whales. We were still hoping things would clear soon, when we got a call from Marie Adams, the town manager, saying the ice to the south was unstable and some whaling crews in that area were pulling back.

We were pretty far north, and everything seemed to look fine from where we were. Then, about an hour later, Polly and I were still on the perch when we got a call from ARF saying that the whaling crews south of us were being rescued, and we should be checking the trail closely. Polly said she would head out and started making her way to the camp area.

Before Polly left on the snow machine, I looked through binoculars at the area around the camp and along the trail heading south toward land, to see if there were any polar bears near the trail. We knew sometimes they

would walk on the trail, because we'd find bear footprints leading off and on to where we had little flags set up. The red flags were intended to help us see which way the trail went as we went zipping along on our snow machines, since everything else was white. We figured such a bear was either just curious or was declaring that this was its territory by knocking down a flag, then heading to the next one to do the same. I didn't want Polly to come around an ice ridge and find a polar bear in front of her, but luckily the trail was, for now, clear of bears.

I started to look at the pressure ridges that were farther away on the ice pack. I saw movement. This didn't seem right. I was looking straight back toward the coast. How could there be movement? There were also some dark spots along the ridges, which are caused when the ice is pushed up, carrying sediment from the bottom of the ocean floor. I picked out one very dark spot on a pressure ridge and watched it begin to move behind another ridge.

I had little doubt that we were moving, but before I could make a radio call, I had to be sure. It was my first year on the census, and calling for a rescue would have been really bad if I was mistaken. I thought, "If that dark piece moves completely behind the other ridge, we're definitely moving." We hadn't been briefed about what it means when ridges move past each other, but it was obvious to me what was happening.

Sure enough, the dark spot disappeared, so I made the call on the radio to our camp. I told George we were moving. Polly wanted to see for herself and headed back to the perch, while George went out on the snow machine toward land to check from there. Craig, who was back at ARF, was monitoring the call and came on the radio to say he would notify the search and rescue team if we needed them. Polly said to hold off while George went to check the trail.

Polly came up to the perch, but was not able to see what I was pointing out. When I suggested she pick out a dark spot on one of the ridges, she couldn't see any ridges moving.

"I'm not saying it isn't moving, just that I can't see it," she told Craig over the radio.

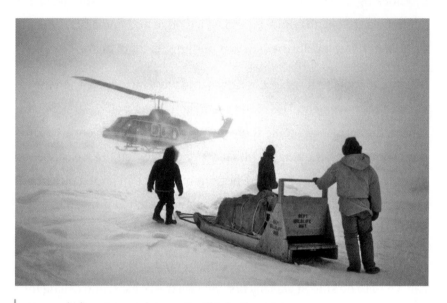

Rescue helicopter reaches us. It will take three trips to move our camp to the ice pack connected to land.

We started back to the camp to wake up Geoff. We were halfway back when George gave us the news on his radio. "Well, we're definitely moving. We have about a quarter-mile of water between the ice floe we're on and the ice pack connected to the mainland, and there's no sign of the trail on the other side." Polly tapped my shoulder as if to say, "Nice job."

Geoff asked Craig to hold off on calling search and rescue till he could take a look, in case there was another way to make it back across to land. But George told Craig he should go ahead and make the call, because there would be no way to cross the water.

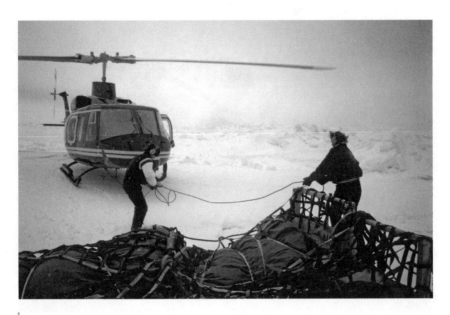

Crew loading cargo.

Geoff took a snow machine to the open water to see for himself, while Polly and I started collecting the most valuable items and putting them in a pile. It couldn't have been more than four or five minutes before the search and rescue chopper landed at our camp. I spoke to one of the rescue crew and explained our situation, letting him know how many people we had in the team, together with a dog named Lubbok. He said we might be able to take everything, but they'd know better in approximately forty-five minutes when they would return after rescuing some people to the south.

A welcome sight at any distance.

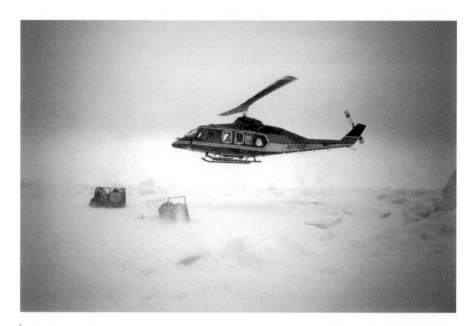

Picking up payload.

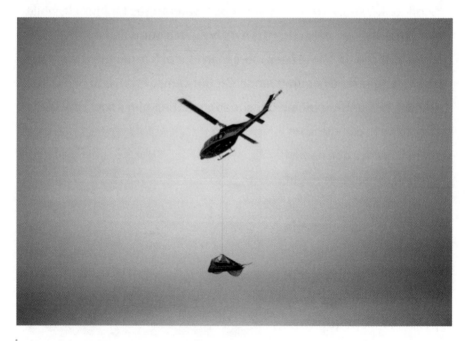

Moving contents of camp to a safe area.

We were in no immediate danger, so we started packing up everything in the camp, doing whatever possible to do it right, but most importantly to do it fast. When Geoff returned, he and I packed the two sleep tents while George and Polly packed the cook tent. It went very well, and we had everything tied on the sleds and ready to go by the time the chopper came back, only thirty minutes later.

As the helicopter was landing I took a photo of Geoff sitting on the end of a sled, with the wind from the blades and the snow swirling around him. Geoff clearly wasn't happy about any of this. For me it was just part of the experience, but with Craig back at ARF, Geoff was in command onsite, and I think he was a little embarrassed to be in this situation. After all, he had been on a National Geographic expedition the year before with the legendary Steger team, retracing the 1909 Peary Expedition to the North Pole. Everybody knew Geoff to be a "he-man" who didn't talk a lot, but people listened when he did, and everybody liked and respected him.

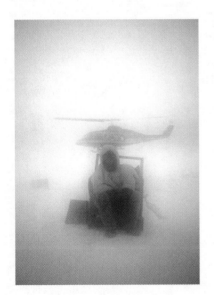

Wildlife biologist and lead crew member Geoff Carroll awaits landing.

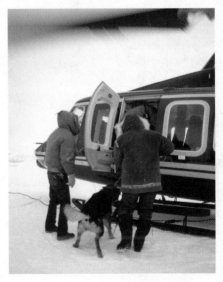

Lubbok the dog and his companions board the last flight of the rescue operation.

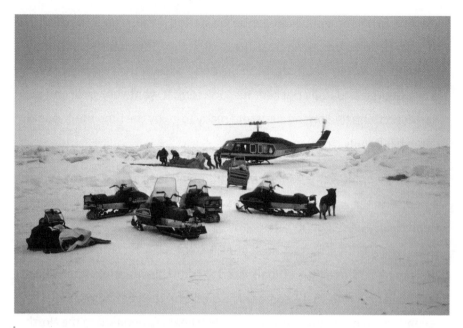

Loading sleds to be hauled away.

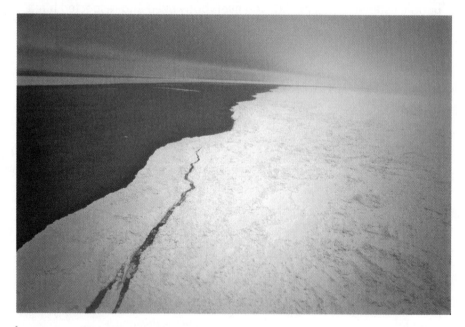

Ice pack we had been stranded on, floating out to sea.

The rescue team proceeded to take two sleds at a time on the nets hanging below the helicopter, then place them down on the other side of the lead, where the ice was still attached to the land. The fifth sled was taken with two snow machines. For the last transfer, the team hauled out the remaining two snow machines as we boarded the helicopter along with Lubbok.

As the helicopter increased in altitude, we could finally take in the big picture, literally. It was only then that we were able to see what we had been stranded on, now floating out to sea on a piece of ice pack that was half a mile wide by at least two or three miles long.

The pilots chuckled when we started making sounds of amazement as we took it all in.

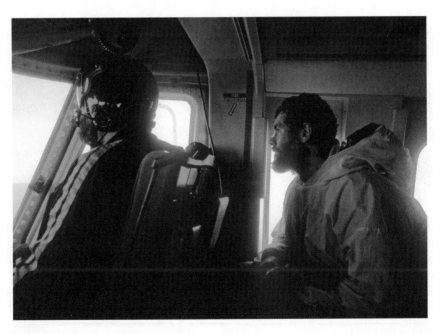

Geoff aboard the helicopter.

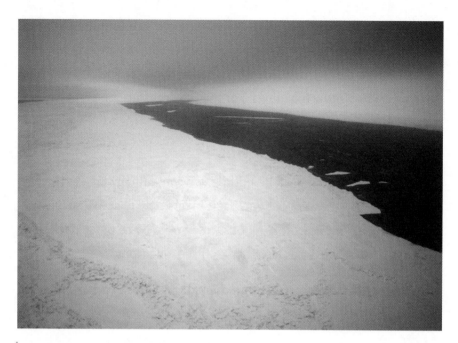

Taking it in as we fly to safety.

One last look at the ice pack we were stranded on.

We made our way to shore-fast ice (called *tuvaq*), where the team set us down, and we thanked the crew warmly. They asked for copies of the pictures I took of them during the rescue and on the flight. We drove the snow machines back to the point, with George dragging two sleds and me another sled with the dog attached on a long leash. Lubbok had been very good throughout the whole helicopter rescue and seemed happy to be running.

The next day, I was at the supermarket and ran into an older man who lived across the street from me. I mentioned what I had been doing and explained what had just happened.

He told me the same thing had happened to his father when he was young and part of a whaling crew. The crew had been pushed out to sea on a very large sheet of ice, camp and all. There were no helicopters or snowmobiles at that time, and their families back in Barrow thought they had died, as weeks went by and no one returned.

It was about three months later when they finally made it back. They'd been too far offshore to make it back in their *umiaks* (wooden boats covered with seal skin), so they subsisted by hunting seals and walrus from the ice pack they were drifting on until they were close enough to make it to shore. Because they were pretty far south of Barrow, they had to make a weeks-long trek on foot to reach home. Their families were overjoyed upon their return.

I guess we had it easy: a radio and a helicopter, a few hours floating, and an airlift back.

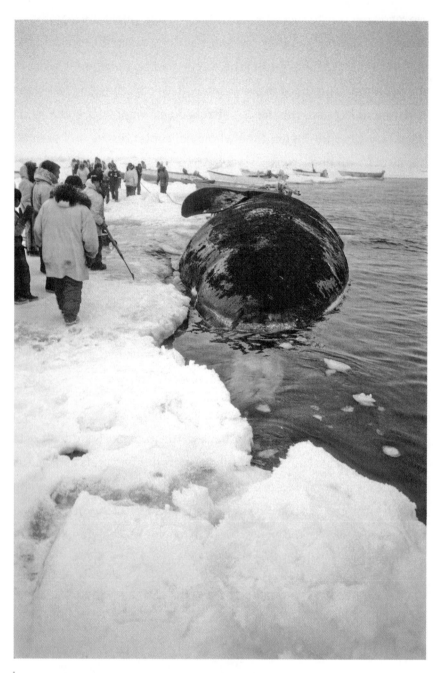

Harvesters at work on bowhead whale.

A WHALE ROSTRUM LEADS TO AN UNEXPECTED FIND

On the day before I was planning to leave Barrow in 1987, Geoff Carroll, the biologist with the North Slope Borough, asked my friend Bill Barber, me, and Mark Leinberger, who worked with the wildlife department, to help him cut the meat off the rostrum—the upper jaw or "snout"—of a bowhead whale.

The city of Barrow was planning on helicoptering the bones of this whale, one of the largest they had ever hunted, to display in front of the North Slope Borough building. In order to do that, it was imperative to reduce the weight of the rostrum by removing the meat and muscle. The rostrum of a bowhead whale makes up about a third to almost half the length of the animal.

Normally the rostrum would have been much cleaner, but because the whale had managed to swim out to sea after being harpooned (and before succumbing to its injury), the meat was decomposing by the time the whalers brought in its remains, about a week after it was struck.

A small plane had spotted the whale carcass, which was then brought in for partial harvesting. The *muktuk* (the skin and blubber) was still fine to eat, so the harvesters removed it from the animal but left the rest.

I had been at the site when the whale's remains were brought in. You could already see bubbling through the open wounds. My guess is that

birds had made the holes when feeding on the whale. The animal's bones were at risk of sinking to the ocean floor once the ice pack melted, so it was important to recover them soon.

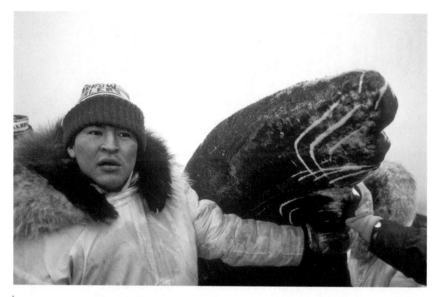

Billy Adams holds bowhead flukes that bear scars from an orca.

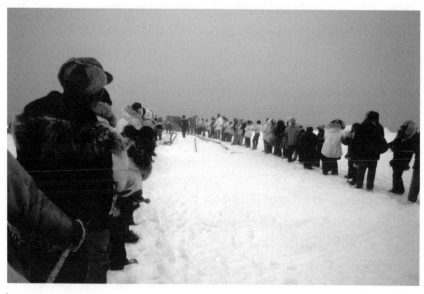

Community helps to move whale onto old ice.

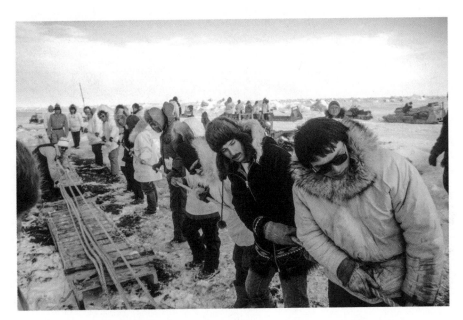

Helping to pull the bowhead using block and tackle (second from right).

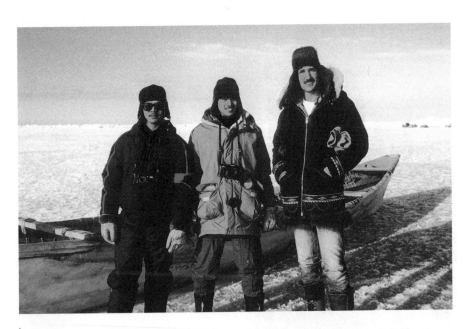

Joined at the site by (from left) Edgar and J. R. Messina, onetime Barrow housemates.

Whale's mouth at close hand.

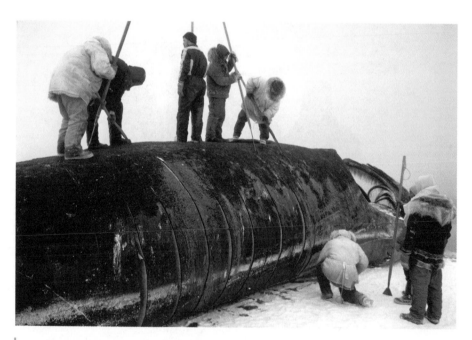

Men at work on partial harvest.

Removing muktuk (skin and blubber).

Part of the whale's fluke.

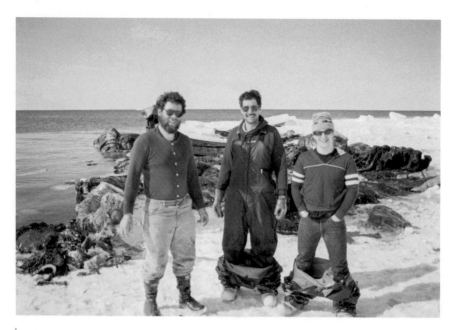

Flanked by Geoff (left) and Marc as we suit up for the event (photo by Bill Barber).

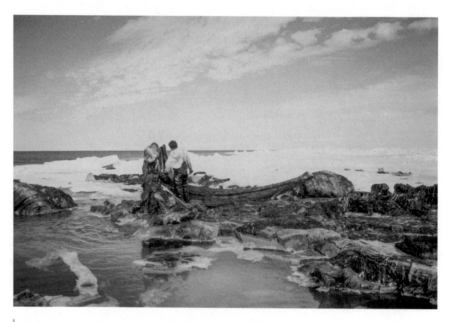

Geoff Carroll examines decomposing bowhead as we start phase two of the harvest.

Cutting extra meat off whale rostrum
—a foul task that took some getting used to.

The four of us headed out on snow machines equipped with lances and ropes, wearing foul weather gear so our clothes would not be ruined. Geoff had warned us that the task ahead would be pretty disgusting, since the meat was already rotting.

In fact, the job was as slimy and unpleasant as Geoff had warned. Even in the open air of the Arctic Ocean, the remains smelled horrible.

As we cut the meat off, I was required to wear a safety belt in order to straddle one of the parts of the rostrum that was at the edge of the ice pack. I remember looking down at the ocean and asking if there were any killer whales in these waters. Geoff shrugged and said, "Probably not."

After our job was done, I was walking beside the whale's remains when something caught my eye. I picked it up.

"Hey, look what I found," I said, showing it to Geoff. He told me it was a harpoon head. I asked if I could keep it, and he said that typically the whaling captains would keep such finds, but because they hadn't harvested the whole whale, and didn't actually find the harpoon, I could keep it.

My surprise find: part of a harpoon point, or more accurately, the front of a bomb lance.

Fast-forward twenty years to 2007, when my mother called to tell me she'd heard a story on the radio in which the head of the whale census in Barrow was interviewed. She said the program explored how old whales might live to be—a subject of interest because a harpoon head found in a certain whale was determined not to have been from the harpoon that recently killed it.

I did some more research online and discovered that the harpoon was believed to have been shot into the whale in the late 1800s. The process of dating the harpoon head was helping researchers determine how long bowhead whales could live in general.

The news story I found was accompanied by a photograph, which pictured a harpoon head that looked very much like the one I had found. I went to my living room to take my own find out of its display case and compare it. To my eyes, the two harpoon heads looked the same.

I photographed the harpoon head I had in my possession, then called Craig George, head of the whale census in Barrow, and sent him a link to the photos. Craig agreed that my harpoon head appeared to be from the same era as the one from the 1800s.

I told him when and how I had found it—that it was from the whale whose rostrum was put on display in front of the North Slope Borough building.

"Oh, the Tukle whale," Craig said, immediately getting the connection. The whale had been named for the whaling captain who'd brought it in, Joseph Tukle.

Fast-forward once more to 2021, the year I decided to write about my experiences in Barrow. While working on one chapter, I contacted Craig George again, as I needed to confirm some factual information about the whale census and bowhead whales. Craig brought up the subject of the harpoon head I'd found, which I learned is called a bomb lance. Craig thought it could be a very important piece, and he urged me to bring it to the attention of the New Bedford Whaling Museum in Massachusetts.

I was able to get in touch with Michael Dyer, the museum's curator of maritime history, who is very knowledgeable. As of now, he said, more research is needed to determine whether the harpoon head I found is the one that killed the bowhead whale in 1987—shot by a whaling crew in Point Hope—or whether it could be from years past, possibly almost a century before.

One interesting note: it seems there are two whaling captains' marks on the harpoon head, something Craig George says he's never seen before. We're curious to know if the bomb lance may have been Tukle's, as one marking reads "TKI," and it came from the whale Tukle brought in. But we're having a hard time verifying it.

The other mark is clearly that of the whaling captain Henry Kinneeveauk of Point Hope, about three hundred miles to the west of Barrow. Craig believes the harpoon head was originally shot into the whale by Henry in Point Hope, but we're still trying to figure out where the second set of markings are from.

In the end, whatever we find out, I am hoping to bring the harpoon head back to Alaska one day, to repatriate it with the people of Barrow, and more specifically the Iñupiat Heritage Center.

PART II
THE EARTHWATCH YEARS

It started with my picking up a magazine in a doctor's office and continued for the next sixteen years, as I photographed some sixty-six environmental projects in fourteen countries. My work with Earthwatch—whether catching a young crocodile in Zambia, or carrying a sedated coyote to a health check in rural Kentucky, or finding the last known location of a turtle that had swum from Baja, Mexico, to a small fishing port in Japan—gave me the chance, as a photographer and a volunteer, to interact with animals and the natural world in a way I had not thought possible.

Earthwatch research expeditions are conducted in a wide range of locations, focusing on a variety of animals and other natural subjects. They're funded largely by the contributions of volunteers, who pay to go on the projects and help the researchers conduct their field work.

For me, it was a win-win situation. As a photographer, I was able to join the research teams in the field for various amounts of time and photograph their projects. In lieu of any payment I'd gain stock photos, and Earthwatch could use them for their publications. The volunteers I met along the way ran the gamut in age and background, from teenagers

to retired people, from aspiring naturalists to teachers, for whom Earthwatch would often help secure a grant to fund their participation so they could later share their experiences in the classroom.

While "volunteer vacations" have become increasingly popular over the years, one thing that set Earthwatch apart was the fact that all its expeditions were centered around research, and all were strictly science based.

After being on a number of Earthwatch expeditions, I realized that even though the subjects studied were unique to each project, the method of studying them was not. Each project used the same scientific method. Over time, I became familiar with that method, making it easier for me to talk to the principal investigators and ask questions about what they were doing. It also made it easier for me, when I wasn't busy capturing images, to assist with volunteer duties and help document the research.

Earthwatch offered me a rare opportunity not only to travel to new places, but also to have access to animals close at hand as they were being studied, whether penguins in South Africa or black bears in Minnesota. It was invigorating to be around volunteers who were as excited as I was to be on the expeditions, and the researchers were extraordinary and engaging scientists who were passionate about their work, people I feel privileged to have gotten to know.

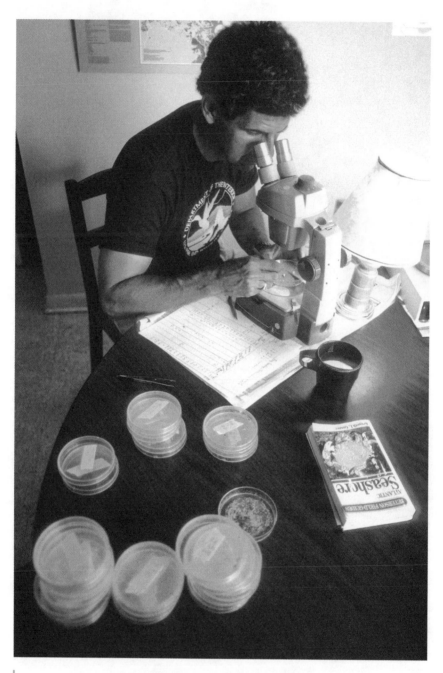

Principle investigator Michael Erwin, on the Virginia Waterbird Sanctuary project, looking at samples under a microscope.

WHEN A MAGAZINE IN A DOCTOR'S OFFICE INSPIRES A MEETING AT EARTHWATCH

Sometime in early 1991, I went to a doctor's appointment where I happened to notice a copy of *Earthwatch* magazine in the waiting room. As I flipped through the magazine, I wondered if I could possibly take pictures for the group that produced it. So when I got home I called to schedule a meeting with Melissa Banta, *Earthwatch*'s photo editor.

Melissa and I talked about the possibility of my participating on a project. She said she'd had a few photographers go on a trip or two in the past.

"We don't have a budget to pay photographers," she told me. "But the room and board are free, and you wouldn't have to pay to be on the project." I told her that was fine, and that I'd be interested in doing some projects with Earthwatch.

I was able to string together four projects for that summer, starting in Maryland and ending in South Carolina. The deal with Earthwatch was that they could use my photos for their magazine, or for any of their publications, but any outside publications would have to contact me and pay me for the usage. This made sense, since I would be paying for all the film and processing, transportation to get to the location, my time on the project, and my work editing, scanning, and captioning the images. Luckily, I was

able to support myself the rest of the year by photographing for schools and other events, which gave me the flexibility to take the summer off.

The first project I went on—my introduction to an Earthwatch field project—was based in Virginia and centered around saving Chesapeake Bay. On the project were four paying volunteers, a researcher and his staff, and an Earthwatch employee named Peter Tyson, who was a writer.

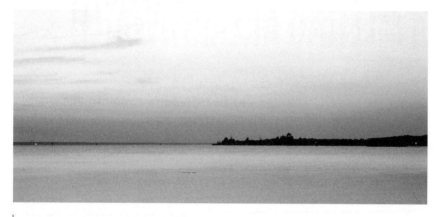

My first Earthwatch field project: Chesapeake Bay, at dusk.

Industry on the shores of the Chesapeake.

We would go out each day to work in the brackish water of the Chesapeake. The Earthwatch volunteers would count blades of grass within a one-meter-square section, then move their PVC square tube to another area and count those blades of grass.

It was pretty tedious work, and I couldn't help but wonder why these people would pay to do it. But I soon realized that this was how science projects get the information needed to understand the environment, information that leads to policies for protecting (in this case) our wetlands, along with the animals that are dependent on it.

While we were on the project, we visited some researchers and volunteers who were rehabilitating sea turtles in the area and were able to see the turtles up close. We also went on excursions on the Chesapeake and checked out some other fauna and flora that lived there, as well as some of the industry along the banks of the bay.

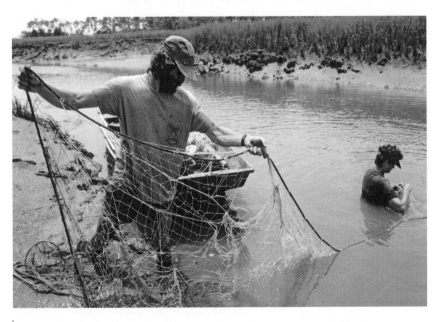

Principal investigator Tony Tucker and assistant Heather O'Conner set nets to catch diamondback terrapins.

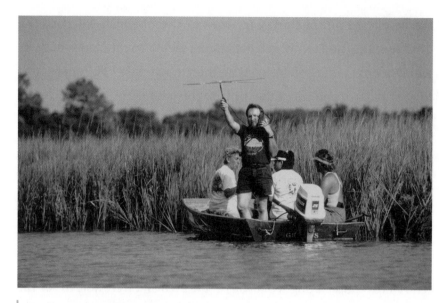

Radio-tracking terrapins.

I remember the day I arrived at the project, at the Virginia Waterbird Sanctuary project house. I introduced myself to the researcher.

"Hi, I'm David Barron. I'm here to photograph for the project for Earthwatch."

"I don't know about this," he said.

"Melissa Banta told me they arranged it with you," I said, getting a little nervous.

"OK, great, there's a motel up the road," he said.

"Uh, yeah, I can't afford to stay in motel," I said.

"Oh, no problem, you can sleep on the couch in the living room, if you don't mind."

"That's perfect."

After a few hours, he said, "You know, I think I do recall something about this." I was thankful he remembered.

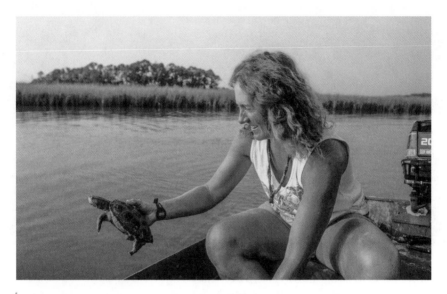

Research assistant Nancy releases a terrapin.

Terrapins on the move.

Brown pelicans catch the sun on Kiawah Island.

Young diamondback terrapin, barely bigger than a thumb.

Tim, research assistant on the terrapin project, holds up ghost crab—an example of local fauna.

Researcher Michael Erwin and Earthwatch volunteers observe bird life at Virginia Waterbird Sanctuary.

Volunteer sifts material from slave quarters of Andrew Jackson's Hermitage, Nashville, Tennessee.

The Chesapeake project, and the three others I worked on for Earthwatch that summer—which involved diamondback terrapins, Andrew Jackson's Hermitage, and the Virginia Waterbird Sanctuary—were fascinating and fun to be a part of. I felt fortunate and hoped I could go on more of them the following summer.

Little did I know that I would end up participating in almost fifty Earthwatch projects over the next sixteen years, and that those would lead to another thirty offshoot projects.

Research assistant Clay Bryant observes an eight-spotted forester caterpillar on the Chesapeake project.

Scissor and pipe artifacts found at Andrew Jackson's Hermitage.

Vial, coins, and buttons unearthed at the excavation site.

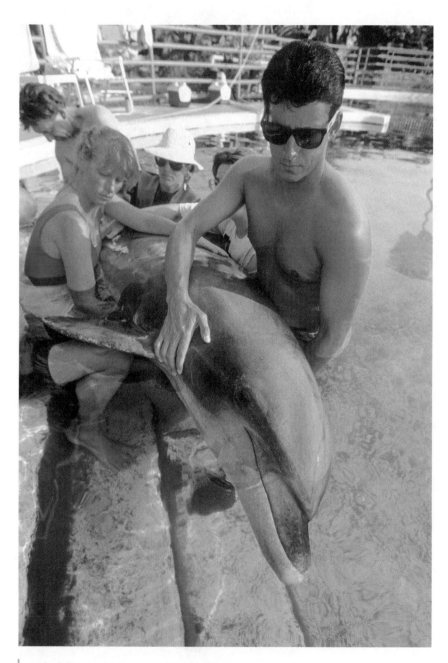

Rehabilitating Freeway, wounded bottlenose dolphin,
at Mote Marine Lab. Sarasota, Florida.

CHAPTER ELEVEN
FREEWAY THE DOLPHIN

It was 1993, and I had just hastily changed from jeans to shorts at the airport after flying in from Boston to Sarasota to work on an Earthwatch manatee project. I didn't want to hold up the person from Mote Marine Lab who was picking me up. Not only was it too warm for jeans, but I wanted to be ready in case I had to jump on a boat for the project I had come down to photograph.

When I got to the lab, I learned that the manatee folks weren't there, but were expected back in about an hour. While I was waiting, I noticed people in a pool, working with a bottlenose dolphin. They were holding him at the surface of the water, apparently so he wouldn't sink.

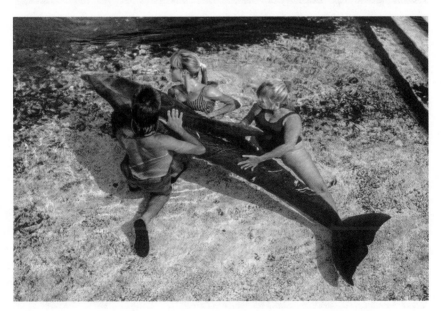

Freeway gets help from volunteers as he recovers from a shark bite.

They told me they had named the dolphin Freeway, after the location where they had rescued him. He had been bitten by a shark. They knew his attacker had been a bull shark, because they'd found some teeth in the wounds. Their hope was to rehabilitate the dolphin so they could release him back into the wild.

Dolphin's wound, identified as from a bull shark.

Jumping in to record the rehabilitation effort.

Fortunately, I was in my shorts, so I didn't have to think twice about getting closer to the action. I went straight into the pool and photographed the volunteers holding the dolphin.

Veterinarian applies antiseptic before giving injection.

Over the next few days, I found myself increasingly drawn to the dolphin rehabilitation effort. I started volunteering for shifts to help care for Freeway on my time off from the manatee project.

There were three to four people holding the dolphin on each shift, with the shifts lasting about four hours. As we stood in about four feet of water, we'd talk to each other while keeping Freeway afloat and making sure the dolphin was OK.

I discovered there was a shark in an adjacent pool, a fact that struck me as weird when I first learned of it. There was a sort of gate separating the two, with open slots that could let water through but were not big

enough to fit a large animal. I wondered if Freeway and the shark could sense each other.

I was in the pool on one of the shifts when we were joined by the dolphin researcher Randy Wells, along with a veterinarian and his team. After assessing the situation, they decided it was time to go to the next step with Freeway to see if he could swim, and how far. Freeway had some water in his lungs and had been listing to one side when the vet had previously observed him. The care team had used a feeding tube to give him medicine and some fluids a few days earlier.

Freeway swims a short distance, with fish as incentive.

The team asked the three of us who were working with Freeway to position one person at each end of the pool and one in the middle. The persons on each end had food to give to Freeway, to encourage him to swim. I was in the middle and remained holding Freeway by myself until they told me to let him go.

Freeway swam to one end, then all the way to the other. On his way back again, he sank to the bottom of the pool in front of me.

There were about ten or twelve people on the deck with Randy and the veterinarian, discussing Freeway's health and his process of recovery. I was waiting for instruction from them, to see if they thought Freeway, after resting for a bit on the bottom, would resume swimming toward the end of the pool. Normally a dolphin can stay underwater for twenty minutes on one breath, but Freeway was compromised and had an issue with his lungs.

Up-and-down, stretching, and range-of-motion exercises underway.

I waited a while, but started feeling like I should bring the dolphin to the surface. Of course, I was a volunteer, not a biologist. But I did ask the care team, finally, "Do you think I should lift him up?"

They said yes. So I reached down, and as I was lifting him, Freeway looked directly at me as if to say "thank you." When he got to the surface

he took a palpable breath. The feeling of visual communication with this animal was amazing. I felt so lucky to be in that spot at that moment.

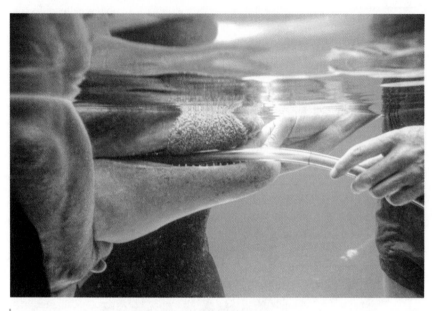

Taking in the nourishment.

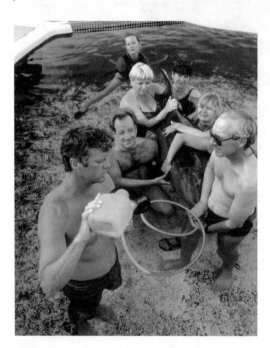

Veterinarian initiates tube-feeding.

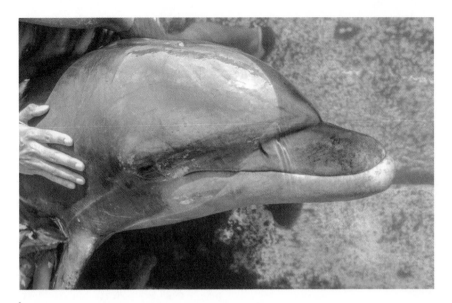

| *On his way to healing: Freeway, held by volunteers.*

People who have had interactions with whales (or other mammals) that they've rescued from fishing lines or nets have talked about the eye-to-eye contact they experienced and what it meant to them. We often humanize animals and think we know what they're thinking. In this situation it wasn't hard to believe that Freeway knew I was helping him.

Three and a half months after being rehabilitated following his original stranding on June 6, 1993, Freeway was released into the wild on September 22. He was seen several times over the next six months and was presumed to be doing well.

Just because different species of animals don't speak the same language, it doesn't mean they can't communicate. Sounds, eye contact, head movements, showing teeth, or moving closer or farther away are all ways of communicating. Anyone who has had a dog knows how much a dog understands, and what we observe from a dog's actions or behaviors. It's as simple as a wagging tail.

One of the things that hit me that day was that all the people standing on the pool deck had been in school for years studying zoology, anatomy, chemistry, and other fields required to become a marine biologist or a veterinarian. Here I was, a photographer with no formal training other than documenting various research projects, yet I was in the right place at the right time to lift Freeway from the bottom of the pool. It was one of the many times I appreciated Earthwatch for giving me access to such phenomenal, breathtaking experiences.

Spotlighting Malawi for ministry of tourism:
visitors on beach walk near Livingstonia Hotel.

CHAPTER TWELVE
MALAWI: A HAIRY SITUATION

In 1988, when I was around twenty-eight, I had an idea for how I could both travel and build a portfolio of stock photography. If I photographed for a foreign country's ministry of tourism, I could exchange the cost of a trip to that country for the use of my photos in the ministry's publications.

In those days, I'd take two slides (transparencies) of every scene I photographed, which meant I'd have one for me and one for the ministry of tourism.

Malawian worker picks tea leaves on the outskirts of Blantyre.

Mesmerizing patterns: guava dries on beach in Karonga.

Paddling dugout canoe on Lake Malawi.

PULLING A WHALE

I wanted to go to Africa, so I wrote to the ministry of tourism for each of the forty-six mainland countries. It was a serious undertaking—finding an address for each ministry, creating a database for keeping track of everything, and writing the best letter I could, to send along with a professional, glossy, one-page portfolio. Not to mention (in those days before e-mail) buying new stationery, properly formatting labels, and finding some really nice postage stamps.

Malawi coastal beach, as seen from hilltop.

I lucked out by first contacting someone from Spain in the World Tourism Organization, who agreed to send me a list of all the addresses of ministries of tourism worldwide.

My uncle Sydney Schanberg happened to be visiting us in Sudbury, Massachusetts, so I asked him to read my cover letter to the ministries. Sydney was a columnist, former editor, and writer for the *New York Times* and had won a Pulitzer Prize for his overseas coverage of the fall of Phnom Penh. Who better to check my run-on sentences, punctuation, and spelling?

I watched him carve up my letter with his red pen. It took only a few minutes. The surgery was swift and comprehensive. He told me that if

you saw a word in a sentence that could be taken away without changing the meaning of the sentence, then you should remove it. His words have been seared into my brain since.

Once the letter was finalized and printed, the large envelopes were each filled the same way, the labels and stamps affixed in my orderly assembly line, and the packets brought to the post office.

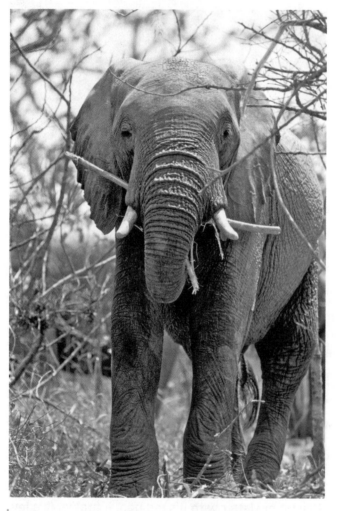

This commanding bull elephant made a false charge at me after I clicked a few photos.

Hippo wading in plant-covered pond, showing who's boss.

Six months later, I received my first letter back, from the Ministry of Tourism in Morocco. Unfortunately, that contact didn't pan out.

It would be October 1992, three and a half years later, before I received a letter postmarked from Malawi. At first I assumed it was from a friend who was traveling, but it turned out to be from Ronald Kahumbe at the Ministry of Tourism in Malawi. He wanted to take me up on my offer. The arrangements were made by fax over a number of months, and I set off on my trip on September 1, 1993.

My plan was to pick up a ticket at the Air Malawi office in Harare, the capital of Zimbabwe (where I was scheduled to photograph on a different project, for Earthwatch) and do some sightseeing. But when I arrived at the Air Malawi office and explained that I was there to pick up a ticket to Malawi in my name, neither the woman in the front office nor the boss in the back knew anything about my picking up a ticket.

Sculptured rock formation, Livingstonia beach, Senga Bay.

I was surprised and a bit worried about what that meant for the future of my Malawi trip. After a long few minutes had passed, the back-office man said, "Oh, I do remember something about that," and instructed the woman to write me a ticket.

After my travel in Zimbabwe was done, I took a bus ride back to Harare. It was long, and when I arrived at 11 p.m., it was pouring rain. I had been camping for over a week, I had a cough, my clothes were dirty, and I looked like hell. I couldn't show up in Malawi like this, so I headed into a very fancy hotel.

Malawi tourists Talia and Eyal at Cape Maclear.

As I walked up to the reception desk, I crossed over some large, beautiful marble squares spanning the lobby. I knew this place would be expensive—I had been spending roughly five dollars a night for a campsite, and the room here was over a hundred dollars. When checking in, I told the clerk I had a flight in the morning and wondered if they could do some laundry by 6 a.m. Yes, they could—a huge relief. So I took a long hot shower and went to bed. It was just what I needed. I woke up the next morning feeling much better. I had clean clothes, and I was ready to head to the airport.

Along the way, I heard some tips about visiting Malawi from other travelers—for example, that it was prohibited to talk negatively about the government, and that women had to wear long skirts and not show too much bare skin.

When we arrived at the first airport, in Lilongwe, Malawi, most passengers (myself included) had to get through immigration before boarding at another gate for a plane to Blantyre. I was worried it would be stressful trying to explain to the immigration people why I had so much camera gear and what I was doing in Malawi, even though I had some letters from Ronald Kahumbe at the ministry.

I was the last person in the immigration line, and I noticed a person walking down the line asking people a question. They all shook their heads in a negative response. Finally, the woman got to me and said, "You're not David Barron, are you?" I told her I was. She said, "I'm from the Ministry of Tourism, and I'm here to get you on your next flight. Follow me."

I grabbed all my gear, no doubt leaving the rest of the line wondering why I was being escorted. I was checked through immigration as the woman explained that I was working for the ministry. Then she walked me through customs, where the agents did a cursory check.

After being the last in line, I ended up being the first of the passengers to get to the gate. I'm sure that as people from the line came into the area they wondered what my preferential treatment was about. Having a contact with the Ministry of Tourism definitely made things easier, and my favorable treatment made me realize they were serious about my trip.

When we arrived in Blantyre, I grabbed my luggage and walked toward the exit, but I didn't see any signs with my name on it. I ended up outside in the dark, thinking there was no one there to pick me up. Finally, a man came from inside the airport and asked me, "Are you David Barron?" He introduced me to Ronald Kahumbe, and we left for the hotel. I got the sense they thought I would be older.

Once at the hotel, Ronald ask me if I wanted to join him in having a drink (later he told me not to get used to it, as the ministry wasn't planning to pay for drinks as part of my trip!). Then he began talking about how bad the government was.

"I thought people weren't allowed to say anything negative about the government?" I said, curious—especially since Ronald was a part of it. He explained that things were changing in Malawi, and that the Ministry of Tourism was very different from the rest of the government.

I hadn't eaten much all day, and I was pretty hungry, but the kitchen was closed. I was very appreciative when Ronald asked the staff to open the kitchen and make me a meal.

The next morning, Ronald and a driver picked me up, and we headed to meet with the Minister of Tourism. On the way, there were protests in the streets. Our driver told us that when he was on the way to pick us up, he'd been stopped by the protesters because they knew he worked

for the government. The protesters were about to turn his vehicle over when he lied and told them he wasn't working that day, and the vehicle wasn't a government vehicle. In fact, we were using an SUV rented by the government for my trip, enabling us to travel to places that were difficult to get to.

Things definitely seemed to be changing in Malawi. By the end of my month-long visit, I'd see people openly wearing UDF (United Democratic Front) shirts, which was very bold, as the UDF was the opposition to the present government.

After we arrived to meet the minister, his colleagues and I sat at a long conference table to talk about the trip. When they began discussing logistics, I realized they were treating this project like a typical familiar-ization tour for travel agents—a tour that traveled in the morning, visited places midday, and returned in the late afternoon.

I explained that, for a photographer, the most important thing was light, and that we needed to change the schedule to revolve around the best lighting conditions—making use of the morning as the sun first came up and the late-afternoon glow. They understood and changed the schedule accordingly.

I learned many things about Malawi during our working trip, including details about the political situation and the power and corruption of the government. One story I heard involved the murder of four people who had run against President Banda in a prior election. I had forgotten some of the details over time, but in writing this story, I researched and found this, from an Associated Press article:

> Cabinet ministers and a legislator were bludgeoned to death with clubs and hammers by police on May 18, 1983. Dick Matange, Aaron Gadama, Twaibu Sangala and lawmaker David Chiwanga were placed in a car that was pushed over a ravine to make the deaths look like an accident.[1]

President Banda and John Tembo, his minister of state at the time, were allegedly responsible for ordering these killings.

In one hotel where we stayed there was a hair salon. That was unusual, and I decided to photograph there. A group of well-dressed women caught my eye, so I went over to them.

"You can't photograph her," said one person in the entourage, indicating a woman who was getting her hair done. I said that was fine, and moved on to photograph a different woman. In the meantime, I learned that the woman getting her hair done was one of the wives of John Tembo.

As we were leaving the salon, someone approached me to say that John Tembo's wife would like me to take pictures of her after all. Tembo's wife had seen me photographing another woman and was annoyed, because *she* was the most important and powerful person in the room.

"Oh, I'm all set, thank you," I said casually, and walked out.

"Are you sure you want to do that?" my guide asked, surprised. "She's a pretty powerful person, and you don't want to make her angry."

He thought I was taking a risk, but he clearly loved what I did. He acknowledged that nothing would likely come of it, since I was a

1. Associated Press, "World News Briefs; Malawi's Founder Held on Murder Charge," *New York Times*, January 6, 1995.

foreigner. If a Malawian had done the same, he said, there would have been serious repercussions.

My response was to say that this woman was married to a man who was responsible for killing innocent people, so to hell with her.

Earthwatchers' cots catch the dawn at Bahia de Los Angeles, Baja.

CHAPTER THIRTEEN
RIDING A WHALE SHARK IN BAJA, MEXICO

It was 1997, and I was in Baja on an Earthwatch project called "Baja Island Predators," led by the zoologist and ecologist Gary Polis. The mornings there were glorious, as the researchers and volunteers would wake on cots lined up on the beach at the water's edge. Purple and pink hues reflected off the water as the day began for all creatures of nature without walls or roof.

Surreal scene on Sea of Cortez, not soon forgotten.

We'd bed down the night before inside our sleeping bags, then wake up in the morning wondering how we ended up on top of them. It would have been fun to watch a video showing us humans an hour or two before we woke up, when the cold of the desert air was gently warming up, and one by one, still sleeping, we'd slip out of our cocoons. As the sun appeared just above the islands on the Sea of Cortez in front of us, the air would heat up quickly, and within minutes everyone would be awake.

Earthwatchers arrive at island to begin a day of research.

This was an idyllic place, especially for a photographer. The memories have faded, but the photos haven't, and when I revisit them, I feel as though I am standing in a time shift, twenty-four years ago.

The research was conducted mostly on the edges of the islands, where the team was studying the relationship between the flora and fauna that lived where the water meets the land. Dr. Polis would talk about how vital that connection zone, and the food chain, was to the life on the island as a whole.

Herring gulls perch on cactus near our living quarters.

Postgraduate "Paco" Sanchez-Pinero holds giant desert hairy scorpion.

On this project we would spend much of our time out on the water and on the islands, gathering data. Back at the research house, we'd process that data using microscopes. The house had a number of large rooms, as well as a long cement patio facing the water. There were sixteen volunteers, plus about seven people on staff, more than any other Earthwatch project I had been on.

Principal investigator Gary Polis and volunteer Wendy affix sticky traps.

Volunteers Weezie (left) and Rachel examine traps through microscope.

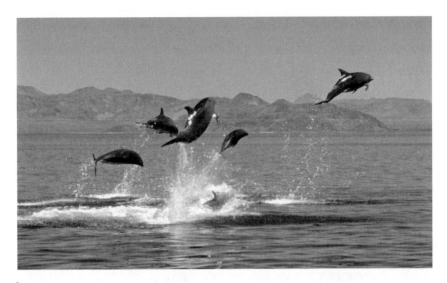

Bottlenose dolphins leap—after our yell for joy upon spotting them.

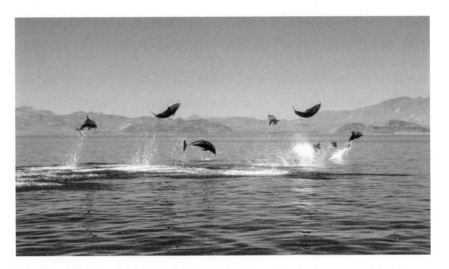

Eight dolphins in the air at once!

One afternoon I was sitting in the research house, in the second room back from the patio, at a table facing the ocean. As usual, I was talking to people while scanning the ocean for marine animals, when suddenly I noticed a dorsal fin. The slow and winding way it was moving and the size of the fin fit what I'd heard people say about whale sharks.

I pointed toward it and stated plainly: "Whale shark!" People in both rooms and on the patio looked in the direction I was pointing. A few echoed me, saying, "Oh yeah, that's a whale shark."

As everyone gathered outside, there was a bit of scrambling regarding boats, what to bring, and so on. It would take ten minutes to get everybody loaded on the boats. Meanwhile, Jon Moore, one of the staff members, said he was going to jump into a two-person kayak to go out and see the shark.

"Who wants to go?" he called out.

I hesitated, because in my role as photographer I wasn't paying for the trip like the volunteers were. But nobody else responded, maybe because they were unsure if it was safe. I waited about twenty more seconds, then said "I'll go, but all of you have priority. I can take photos from the project boat." When there were still no takers, I jumped into the kayak with Jon.

Jon and I proceeded out toward the animal, with Jon in back and me up front. We had brought our snorkel gear, and I had my Nikonos underwater camera. As we approached the shark, it seemed to notice us and turned in our direction.

Jon and I stopped paddling, because it was headed right for us.

I have to admit I was little freaked out. I asked Jon if he was *sure* it was a whale shark (a species that doesn't pose any danger to humans). He said he was pretty sure. I said, "Because if it's not, we're screwed!" The animal that was coming toward us was awfully big, and if it were a toothed predator, it might not go well. And I was in front!

Because of the way the sun hit the water, it wasn't until the shark was passing right beside us that we finally saw the telltale spots on its back that caused us both to sigh in relief.

The whale shark swam by us, then turned around and swam directly underneath us.

At that moment I captured an underwater image of it. It was fascinating to see how curious this animal was about checking us out, and so cool to have a twenty-five-foot sea creature swim right under our flimsy little kayak. From its size, we could tell it was young, since the adults grow up to some sixty feet long.

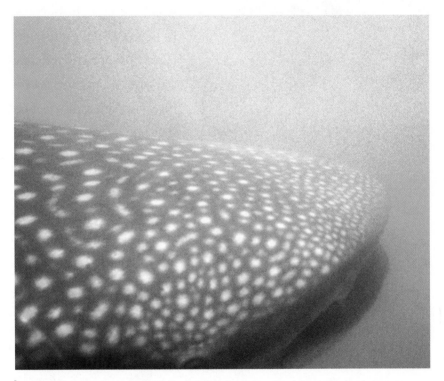

Whale shark swims alongside our kayak.

We followed the shark, thinking we might be able to ride it. The idea was to get our snorkel gear on, then anticipate where the shark would be heading and jump off the kayak to try to meet up with it. I was ready first, so I got off the kayak and swam out a bit until I saw that the shark was headed my way.

I looked underwater to see if I could spot it from that vantage point, but it was still too far away. I popped up again a few times to make sure it was still moving in my direction. When I finally was able to see it underwater, my God, it looked massive!

In honor of an experience: a temporary drawing on my arm (courtesy Jon Moore) shows me riding a whale shark.

The animal was swimming back and forth with a kind of movement that said "shark," which my brain instinctively reacted to as a danger sign. I had to consciously tell myself that this was a filter-feeding animal—one that wanted to eat plankton, not me—in order to keep from freaking out.

The moment finally came when the shark swam right by me. I grabbed onto its dorsal fin. The animal was pulling me along, and I wondered if it would take me farther down into the water. I wasn't thinking about something so mundane as breathing—I was too distracted by the fact that I was being pulled along by such a massive (but docile) fish.

It started to move back and forth pretty rapidly, and I realized it probably wanted to lose the uninvited passenger that was slowing it down. It succeeded, and I fell away from it.

I wasn't sure if the shark was pissed off, as it began approaching me on my left side and was moving in at an angle, with its head coming closer and closer. I swam a bit to the right to give way to it. Then it leaned to the right and slowed almost to a stop.

I was a little worried, wondering what its intentions could be. Regardless, I proceeded to do one of the dumbest things I have ever done. I started to wave at it! After a few seconds I realized how stupid that was, waving at a fish.

In the end, it became clear that this whale shark was just a curious animal that knew I was no threat to it, but a big enough creature to check out. After it swam away from me, Jon ended up catching a ride from it as well, before it knocked him off too.

As we headed in to shore, the boat filled with researchers and volunteers was just on its way out.

Jon and I had gotten caught up the thrill of the situation, but we both knew it was a no-no to interact with animals that way. We were visitors in their environment, and touching animals in the wild is not acceptable behavior. The best and only practice, as I know now, is simply to observe these incredible creatures—and leave them alone.

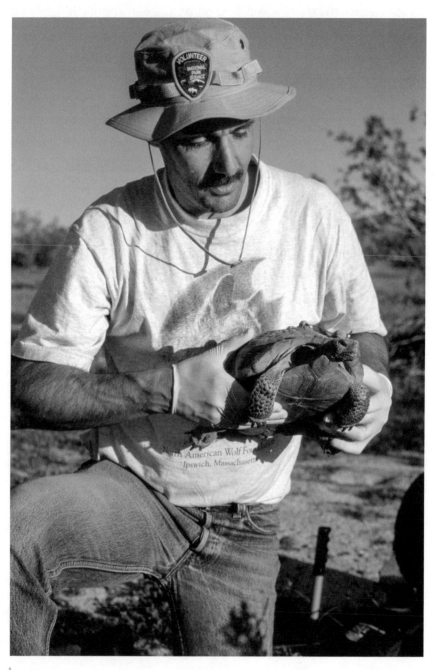

Admiring Marley, after bestowing his name in the desert.

CHAPTER FOURTEEN
MARLEY THE DESERT TORTOISE, JOSHUA TREE NATIONAL PARK

In 1998, I planned to photograph two Earthwatch projects, one on the gray whales of Baja and another on desert tortoises in Joshua Tree National Park, in that order. But Gillian Bowser, the principal investigator on the desert tortoise project, suggested that I might be wise to come to Joshua Tree on an earlier team, because by the time I was originally scheduled to be there it would be blazing hot.

The gray whales project, on the other hand, was an ocean expedition. Even in hot weather it would be very comfortable. So I switched the order of my trips.

The decision turned out to be fortuitous. When Gillian picked me up at the Los Angeles airport, she told me there was an unusual desert bloom happening. The extent and timing of spring wildflower blooms in Joshua Tree vary from one year to the next, and this year's turned out to be the kind of rare and very extensive bloom that happens only once every fifty years or so.

Dune Primrose in rare desert bloom.

When we arrived in Joshua Tree, I went out into the desert, and it was as spectacular as Gillian had described. The bloom was perfect for taking photos.

Cleft-leaf wild heliotrope.

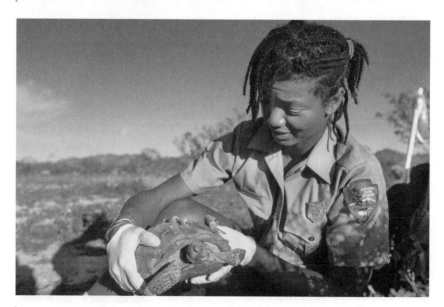

Principal investigator Gillian Bowser gets down to work.

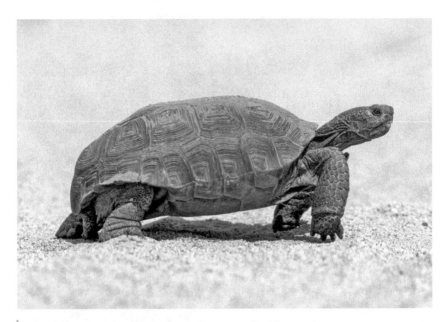

*Desert tortoise makes a rare appearance. It will spend
95 percent of its life in an underground burrow.*

Teddy-bear cholla in golden light.

Gillian's shoes, after our hike through a muddy stretch.

Patterns in dry desert floor.

As I got involved with the project, I was able to do some work with a researcher named Kathie Meyer to track tortoises that had radio tags. We tracked the animals to their burrows, where the goal was to remove them and check on their health.

Kathie demonstrated the process to me and asked if I wanted to try. You had to reach pretty far into the burrow in order to grab the tortoise and pull it out, which was not easy.

It ended up taking me close to thirty minutes. Each time I'd try to pull on the animal, it would push up with its legs, so its carapace (the upper shell) would come in contact with the ceiling of the burrow. When that happened, the animal would not budge at all.

Green lips give away an appetite for plants.

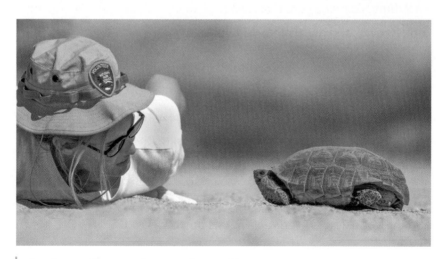

Up close and personal: researcher Kathie Meyer observes desert tortoise, who studies her back.

| Affixing ID tag on tortoise's carapace.

One technique I learned was to tickle the tortoise's axillary region (the equivalent of our armpits), and when the animal relaxed, to give it a pull. Each time, I'd manage to pull it about half an inch at most. This routine took forever, and my arm started hurting.

Along the way, I noticed something. I said to Kathie, "Hey, we're looking for a female, right? Because I'm feeling a big indent in the plastron [the belly part of the shell], so this has to be a male." I knew that male tortoises have an indent at that spot, enabling them to climb onto the back of a female's carapace and be close enough to mate.

"Well, that's weird, because we're looking for a female," Kathie agreed. "So there must be two animals in this burrow."

I finally got the tortoise out, and sure enough, it was a male. My arm was swollen from pulling on it all that time.

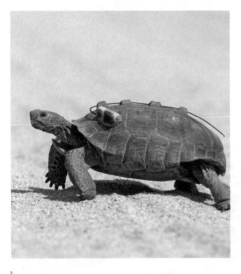

Radio tag and antenna held in place by clay mounds.

Kathie explained that because it was a new animal, and not the one we were tracking, I was invited to give him a name. I suggested we name him after one of my favorite musicians, Bob Marley. So that's how one unexpected tortoise found himself registered in the data logs as a reggae god.

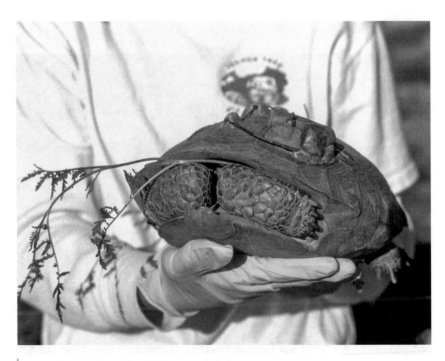

Keeping a grip on tasty plant material.

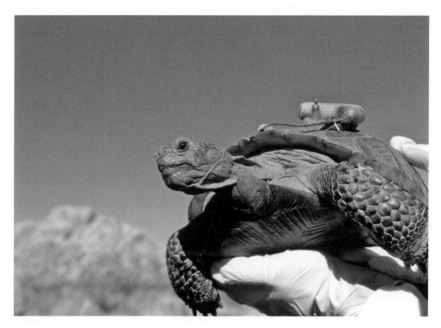

Radio-tagged tortoise against desert sky.

Early morning moonrise silhouettes Joshua trees.

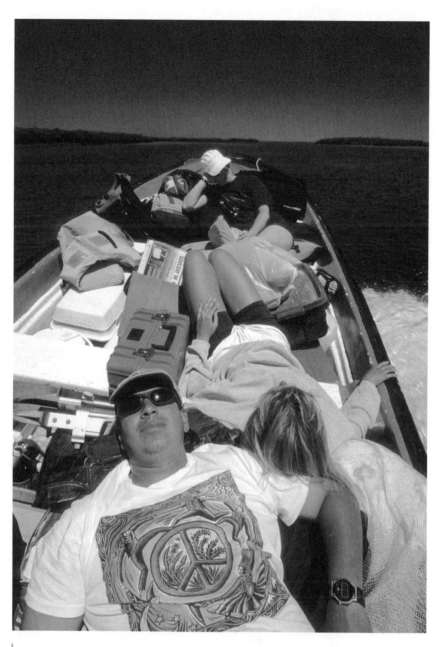

Principal investigator Paco Ollervides with (from front) volunteers Ladonna Wyatt and Beverly Hinchorek, relaxing on a boat ride.

CHAPTER FIFTEEN
"GRAY WHALES OF BAJA"
—WITH NO WHALES

It was 1998, and I was on an Earthwatch project in Baja, Mexico, to photograph a study on gray whales. The researcher, Francisco "Paco" Ollervides, was a great guy who was a lot of fun to be around. Thank goodness he was so cool, because the project lasted about a week— without our seeing a single whale.

I had been to the area before, so the stunning scenery was not a surprise. For this project on the west side of Baja, we were camping out on Isla Magdalena, and I was very excited about the prospect of seeing gray whales.

Our campsite on Magdalena Island.

Beverly inserts cot into her tent.

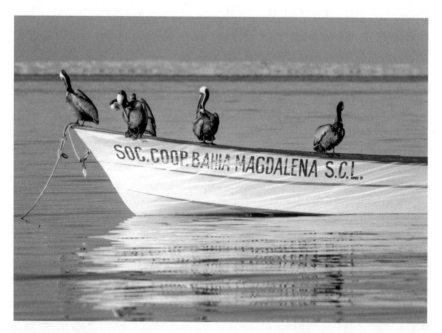

Brown pelicans claim a spot on Magdalena Bay to clean and warm up.

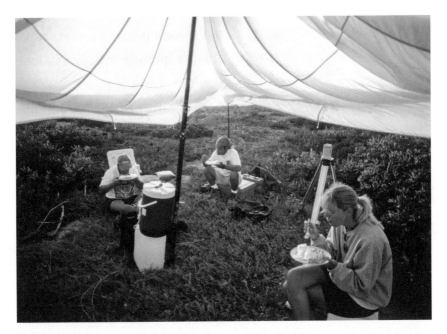

Paco (left) with volunteers Sean Sanders and Ladonna, enjoying dinner under parachute cover.

Paco proves a sand dune makes a great jump and slide.

Baja's dreamy desert sands.

But it soon became clear that we weren't spotting any. It was a long way to travel not to see a whale, but in fact we had an amazing time. There are always things to see in an ocean, and things to do in and around it.

One night after dinner we played a drinking game, then talked about life and looked at the stars. Just before bedtime, the researcher, Paco, was heading to his tent, and I said to him, "Paco, we should move the cook tent because of the tide—it will get flooded by morning."

"Oh no, it'll be fine," he assured me.

Unfazed: Paco carries on, with unexpected armrest.

In the morning, I headed to the cook tent only to find Paco sitting on a chair, his feet in water, and his arm on a boat that had drifted under his tent into the kitchen area. It was an odd and amusing sight.

Paco looked at me and said, "I guess you were right."

Ladonna and assistant Mario Hernandez admire Paco's high-tide kitchen.

Paco wades through seawater to climb aboard.

Pristine Baja beach.

Abstract art: sand dune formations.

Six months later or so, I was on a project down in that same area, at a time when whale sightings were not expected. While we were going out on the boat to do some work on turtles, a whale came right across our bow. I remember thinking, "I come here during whale-sighting season and don't see a single whale, then get here in the off-season and manage to see one."

You never know what you're going to find on these projects, and expectations can sometimes run high. But I discovered over the years that keeping your expectations lower—and being open to the unexpected—often leads to a better experience.

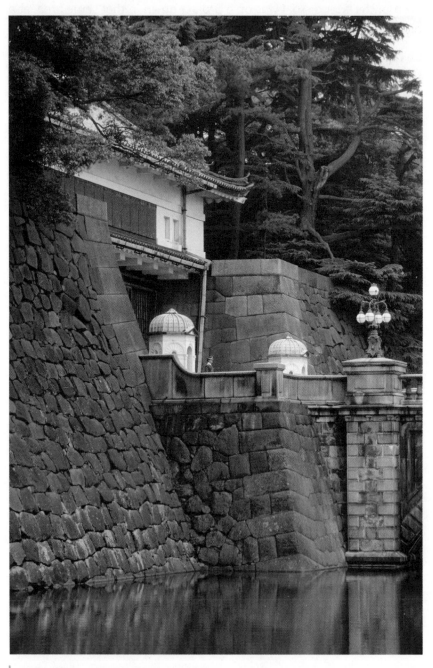

Imperial Palace walls, Tokyo, Japan.

CHAPTER SIXTEEN
THE EMPEROR'S WAVE, TOKYO, JAPAN

Sometimes when I travel I'll see things I find really interesting, but I won't understand their full meaning until years later, when I learn more details through reading or when someone points them out. Then it becomes a whole new discovery.

In July 1999, I was on a trip to Japan with marine biologist J. Nichols and his wife, Dana, to photograph a loggerhead sea turtle nesting site on Yakushima Island and visit a local researcher. We also planned to go north, to the city of Sendai, to find the last location of a satellite tracking device attached to a loggerhead turtle that had swum for the better part of a year, from Baja to Japan.

After I landed at Narita Airport, I took the train to the home of some family friends—Wally (whom I had known since I was three or four) and his wife, Nobuko. I arrived pretty late in the evening. Wally and Nobuko took me out for a quick bite that evening, and the next morning wrote down an itinerary of places I should visit. They suggested a first stop at the Emperor's palace, then gardens, shops, and temples.

On his way to work, Wally dropped me off at the imperial palace, which is open to the general public only on New Year's Day. The rest of the year visitors can see the surrounding moat and swans, which are beautiful.

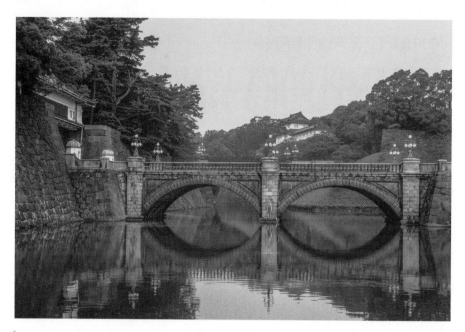

Palace bridge and moat.

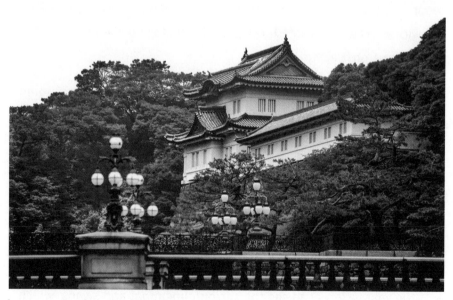

The stunning Imperial Palace.

Picture of elegance: swan glides through moat.

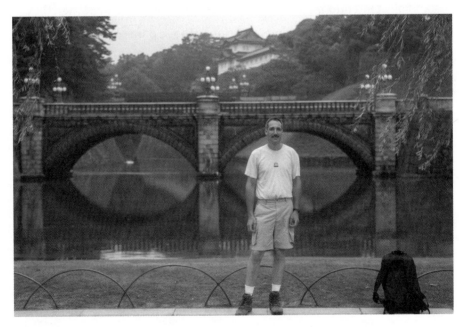

At the palace, awaiting the day's events.

As I was taking photos of the swans, a Japanese photographer started talking to me, and I asked him what the emperor's name was. He said he didn't know, so I wondered if he might ask the guards. He seemed reluctant, but agreed to approach and talk to them.

When he came back, he told me the guards didn't know the emperor's name either, but they did tell him that the emperor would be coming out of the palace about an hour later, at 10:40 a.m. The photographer proposed that we head over to the Ginza district and walk around in the meantime.

In the Ginza district, I noticed a Canon building, and since I was a Canon user, the photographer said he'd introduce me to the staff if I liked. I'd been having a problem with my 24–70 Canon lens, and he thought the staff would probably take care of it.

We walked into the Canon office and found most of the employees standing at attention, listening to their daily morning briefing. When they came over to us it was obvious they knew the Japanese photographer, and he made introductions. One employee looked at my lens, then took it in the back for a few minutes and returned with a loaner for me to use while they fixed mine.

We were walking farther into the Ginza area when I noticed the time.

"We should get back," I said. "I don't want to miss the emperor coming out." The photographer told me not to worry, since that wouldn't be happening until 10:40. But he could tell I was concerned, so we went back a bit early.

Exactly at 10:40, the gates to the moat opened up, and the emperor's motorcade appeared. It passed right in front of us. There were maybe four or five other onlookers in the area. The emperor had his window down, and I couldn't believe that he starting waving to us as he passed by.

If I hadn't asked the photographer to speak to the guards, I would have left the area and never known that the emperor would be leaving the palace. It was an incredible thing to see. The photographer told me he had seen the emperor once before, when he was photographing an event, but most Japanese residents had never seen him.

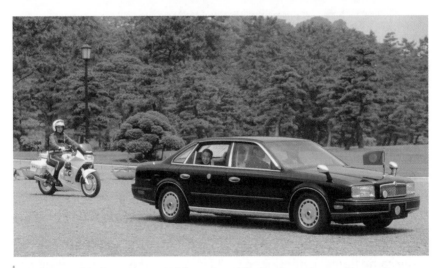

Emperor Aki Hito appears in his motorcade. A yellow chrysanthemum, the Imperial Seal of Japan, can be seen on the front plate.

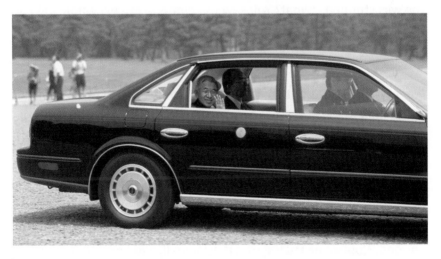

The Emperor waves at visitors to the palace.

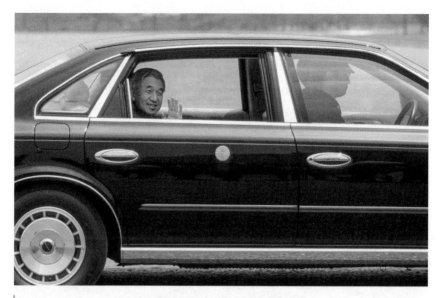

Note the Emperor's symbolic chrysanthemum on rear door.

I continued with Nobuko's suggestions for sights to visit, then made my way back to Wally and Nobuko's apartment late in the afternoon. When Wally came home, I mentioned that I had seen the emperor. At dinner he brought it up: "Nobuko, did you hear that David saw the emperor?"

She was stunned. "What? You saw the emperor? In my whole life I've never seen the emperor. I don't even know anyone who has seen the emperor."

Years later, I found out that Nobuko's family was enamored of the whole idea of having an emperor, and they revered him. Her family was shocked that I had seen him, never mind that it happened on my first day in Japan.

While Wally and Nobuko and I were talking, I mentioned that neither the photographer nor the guards knew the emperor's name, which I thought was odd. Nobuko explained that they actually did know his name, but that it's taboo to say it aloud in public as long as the emperor is alive.

In public, people were expected to refer to him as *Tenno*, which means "emperor." She said his real name was Akihito, the son of Hirohito.

Years later, Norm Sears (Wally's uncle)—a family friend who was my dad's age and knew almost everything you could think to ask about the world—saw the images I had of the emperor. He pointed out a chrysanthemum symbol on the car the emperor was riding in and explained that it was the emperor's symbol.

Norm told me that the symbol was on all the Japanese battleships during World War II to indicate that they belonged to the emperor. On the license plate of the emperor's car, there were no numbers and no Japanese symbols, just a chrysanthemum.

It was fascinating to learn all those details about what I had seen, so many years later.

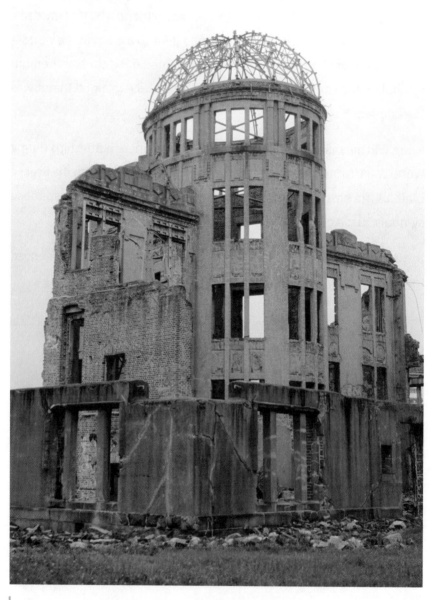

The Atomic Bomb Dome, intentionally left untouched as a
reminder of the events of 1945, Hiroshima, Japan.

CHAPTER SEVENTEEN
A CHANCE DISCUSSION ABOUT THE ATOMIC BOMB, KYOTO, JAPAN

It was July 1999, and I was in Kyoto, Japan, going up the most amazing escalators I had ever ridden. The whole design of the Kyoto train station was intriguing, with so many things I had never seen in architecture before.

A Japanese man happened to start talking to me, as he knew immediately I was an American. He spoke English perfectly because he'd gone to school in California. As we made conversation, I mentioned that I had just arrived from Hiroshima.

I had taken the opportunity to arrive a few weeks early to do some traveling and see places that were not part of the turtle project itinerary, including Kyoto, Nara, Miyajima, Iwakuni, and Kamakura. I also knew I would not travel to Japan without visiting either Hiroshima or Nagasaki.

As I talked with the Japanese man in the Kyoto train station, I asked if I might find a professor in Tokyo to speak to about World War II, and the dropping of nuclear weapons, from a Japanese point of view. The man said he wasn't sure about locating a professor in Tokyo, but that he himself had studied World War II history and could probably answer some of my questions. So we decided to grab some lunch at one of the many food kiosks at the train station.

Even the entrance to the station is impressively designed.

Kyoto Station, Japan.

The first level from above.

I started by mentioning that my dad and I used to have discussions about the Americans dropping atomic bombs on Hiroshima and Nagasaki, and that he would explain to me why he believed it had been necessary. I didn't agree with him, and questioned whether there was a way we could have accomplished what was needed by dropping the first nuclear bomb on an island, which might kill a few soldiers, as opposed to dropping it on the much more populated mainland in Japan. That way, Hirohito would understand the power the United States possessed.

My dad noted that the number of bombs was limited, and it had taken a long time to build them. It wasn't known if any or all of them would successfully detonate. He maintained that dropping the bomb as it occurred was better than the alternative—invading the mainland—which would have led to many more deaths on both sides. He said that Hirohito would not have surrendered if the bomb had fallen on an island.

When I laid out my argument to the Japanese man, he told me that by that time in the Second World War, the Japanese had pulled back from the islands to the mainland, leaving no Japanese soldiers on any of the islands, other than a few who hid in caves and were discovered decades later. The man agreed with my father that Hirohito would not have surrendered if the atomic bomb had fallen on an uninhabited island, or on one with a limited number of Japanese soldiers. In fact, Hirohito failed to surrender even after the bomb fell on Hiroshima, and did not do so until after the second bomb was dropped, on Nagasaki.

It was gratifying to hear my dad's thinking on this important subject echoed by a Japanese World War II scholar.

There's a certain reverence I feel about both Hiroshima and Nagasaki. It was my country and my grandfather's generation that made the decision to bomb them. It was my father's generation that carried it out. I had always wanted to learn as much as I could about the effects of these actions, taken to save American lives. But at what cost?

When I was in Hiroshima, toward the end of my first day of visiting Peace Memorial Park, it had begun to rain heavily. I started back toward my hotel, taking a few photos along the way of people riding bicycles while getting drenched.

One young woman walked up to me and put her umbrella over us both, so my cameras and I wouldn't get soaked. Her command of the English language was limited, and my Japanese was nonexistent, but we were able to cover the basics enough to make plans to have dinner that night (after we each bought a translation dictionary).

Her name was Ayako Matsuo. Before dinner, I asked about her views on the bombing of Hiroshima. She said her grandfather had died of the

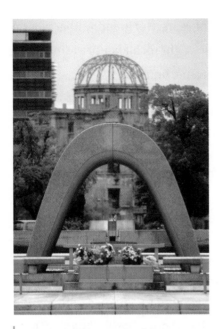

Memorial Cenotaph with Atomic Bomb Dome in background, Hiroshima.

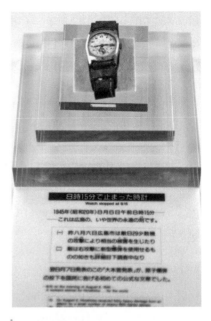

Watch stopped in atomic bomb blast at 8:15 a.m., August 6, 1945.

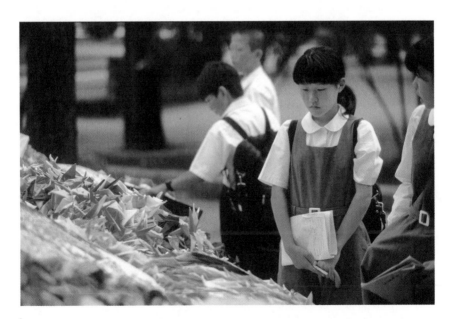

Contemplating paper cranes at Children's Peace Monument, Hiroshima.

effects from the bomb after a number of years. Her grandmother was no longer living, but I asked if her mother might recall her grandmother's thoughts about the dropping of the atomic bomb.

The next day we met again, and using her dictionary, Ayako relayed something her grandmother used to say: "War is futile."

I was struck by how different Japanese sentiments about war seemed to be, compared to the United States. In Japan, people think of the overall picture, the essence of an event, whereas in the United States we speak of winners and losers.

As I left the Kyoto train station and continued on my trip, I was grateful that the project with J. Nichols had taken me to Japan, giving me the opportunity to see Hiroshima—and to have some discussions I had long wanted to have.

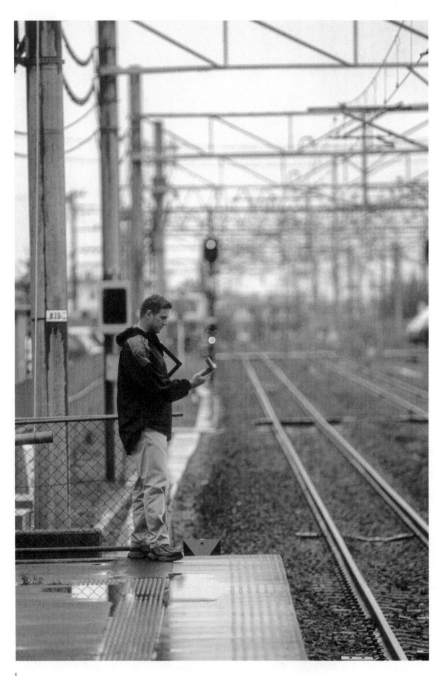

Marine biologist J. Nichols checks GPS at train station.

CHAPTER EIGHTEEN
SEARCHING FOR A SEA TURTLE NAMED ADELITA, SENDAI, JAPAN

Adelita is a noble name, one that was given to female soldiers in Mexico who fought bravely in battle alongside the male soldiers they cared for. It is a fitting name for a loggerhead sea turtle (*Caretta caretta*) that would cross the Pacific Ocean to Japan from Baja, Mexico, to fulfill her life's duties.

J. Nichols had bestowed this name on Adelita when she was fitted for a satellite tracking device in the waters off Baja. J. was looking for another level of proof that the loggerhead turtles were making their way back to Japan after spending twenty-five to thirty years off the coast of Baja.

The theory is that loggerhead turtles are hatched on a beach in Japan, then get caught in the Kuroshio Current and end up off the Baja coast after about five years. When they hatch, the turtles are around one and a half inches in diameter and grow to about seven to ten inches in diameter after five years. They feed offshore mostly on pelagic red crabs for twenty-five to thirty years, eventually growing to about three feet long. During that time they never come onshore.

It's difficult to decide when to attach a tracking device to a loggerhead turtle, because you don't know when it's going to start its journey from Baja back to Japan. The turtles' return trip to Japan is approximately a year long, during which time the animals are actively swimming. On the

course of their journey, they spend about a month near Hawaii, where they may feed to replenish themselves.

When the turtles arrive in Japan, they return to what most researchers believe is the same bay they entered the day they hatched. Then they mate in the water, and within twelve to seventeen days the females crawl up on the beach, dig a hole for their clutch (or group of eggs), lay their eggs, and bury them before returning to the ocean. The females repeat this process multiple times, mating with different males and laying two to six clutches of up to 130 eggs each.

I met up with J. and his wife Dana right before heading to Yakushima Island, off the south coast of the mainland, near Kagoshima. We spent some time with sea turtle researchers Dr. Naoki Kamezaki and Kazuyoshi Omuta at Yakushima, where I had my first opportunity to see nesting sea turtles.

After leaving the island, we headed toward Sendai to try to set eyes on the last location shown on Adelita's satellite track. The ARGOS satellite transmitter that was put on Adelita in Baja had tracked her to this area, and we wanted to see the exact place where the tracking indicated Adelita had made landfall.

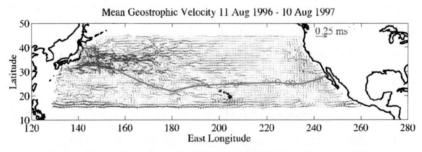

Map of loggerhead sea turtle's trans-Pacific route.

We headed up toward Sendai by train until J. thought our GPS coordinates were close, then got off and continued on foot. The GPS units of that time didn't update as fast (and weren't as accurate) as the handheld devices we have today, so it was hard to determine the exact location.

J. and his wife, Dana Nichols, plan our route.

Following the GPS through a rice field.

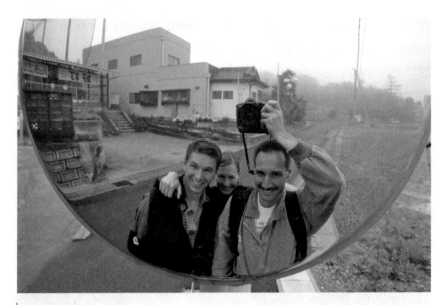

A time of reflection: with J. and Dana in road mirror.

At the first port we came to there was a very large ship docked, so we asked someone from the ship if he could tell us their more accurate GPS reading. The coordinates suggested that we needed to move farther north.

The next port was Hamahata, where there were some big boats, not the type J. said we should be looking for. Because the GPS was still a bit off target, J. checked with the people in the port building, who brought out some maps and told us there was another port even farther north.

By then it was late in the afternoon. When we started walking away, and the port officers realized we were on foot, one of them came out and offered us a ride.

When we arrived at the next port, Isohama, we discovered that, finally, the coordinates were exact—that is, within twenty to fifty feet. Sure enough, the boats in Isohama were just what J. had expected them to be: small squid boats. Now that we knew we were in the right location, we spoke with the port officers and explained why we were there. We

asked if they could inquire around to the boat captains to see if anyone had possession of Adelita's satellite tag. I gave one of the officers my watch as a sign of goodwill.

J. (right) asks second mate for ship's GPS coordinates.

Looking over map with Hamahata Port officials.

J. checks GPS again at Hamahata Port.

This was clearly where Adelita, or at least her transmitter, had ended up. It was a straight line and a fast track that was recorded on the GPS, and a swimming sea turtle doesn't swim that fast or in a straight line. So J. had surmised that Adelita was almost certainly caught in the nets of a squid boat, as many sea turtles are. She would have been brought on board, where the captain most likely took the satellite tag off the animal and either kept it as a souvenir in his house (from which the satellite transmission would not be received) or destroyed it.

Found at last: J. with Isohama Port officials at the location where Adelita arrived on a shrimp boat.

That may have been the end of our search, but there are always some things that happen on these research trips that are memorable, beyond the work you've come to do.

The three of us were staying at a beautiful four-hundred-year-old hotel in Sendai. Situated in an old wooden building, it had little walkways and natural hot baths from the local hot springs running through it. J. and I

tried one of the hot baths, but it was so hot we couldn't stay in it very long. We came out looking like lobsters.

Shrimp boats at Isohama Port—just the sort of vessels J. expected to find.

A memorable dinner (from right, in matching kimonos): J., Dana, and I are joined by owners of four-hundred-year-old natural hot springs hotel.

One night, the owners of the hotel asked if they could have dinner with us and said they would prepare everything. We all dressed in traditional Japanese kimonos. The meal was exquisitely presented and tasty, and after dinner some little treats were brought in for dessert. We didn't know exactly what they were, but assumed they were candies.

We each put one of the white candy-like balls in our mouths, expecting a sweet taste, but instead . . . they tasted like fish. J., Dana, and I just looked at each other, wondering how we could get these treats out of our mouths without insulting our hosts.

Later that night, when I got into bed, I felt something odd. Under my pillow I found two of these treats. I knew Dana must have been the culprit, sneaking into my room and putting those things in my bed. I was annoyed and laughing at the same time.

The next morning, I watched the women who were preparing breakfast as they went back and forth, setting up the plates and food in the same room where we had dinner the evening before. The breakfast was for us alone, as we were the only guests at the hotel.

I took note as the servers brought in some yogurt. Knowing where Dana would be sitting, I snuck in after the servers left and dropped those two wonderful treats into her bowl. Then I quietly returned to my room and waited for J. and Dana to make their way to breakfast, where I non-chalantly joined them. Dana began eating the yogurt, only to notice something odd in her mouth.

"Oh my God, what is this?"

She quickly took the morsel out and looked over at me, laughing as she realized what I'd done, trying to get the sour taste out of her mouth.

Principal investigator J. Nichols logs sea-turtle toe bones in Baja.

CHAPTER NINETEEN
TAGGING SEA TURTLES IN BAJA—AND TANGLING WITH MEXICO'S MILITARY

It was still 1999, less than a day before I'd be heading to Baja on the sea turtle tagging project with J. Nichols, when I decided to buy a new lens for my underwater camera. I'd been to Baja a number of times before and knew that the waters of the Pacific Ocean were not as clear as in the Caribbean.

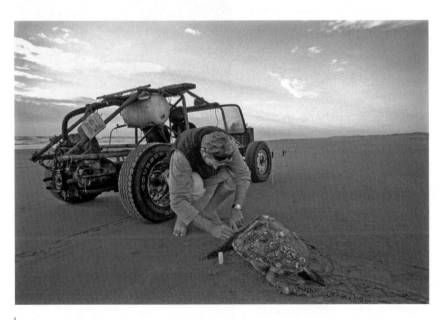

J. takes skin sample from dead loggerhead sea turtle.

One way to get good photos of J. releasing a sea turtle underwater would be to get extremely close to him and the turtle, within a foot or two—and that would mean having a very wide wide-angle lens, such as a 12mm, which covers 180 degrees. I quickly found one at a California photo store and had it shipped overnight to the Logan Airport Fed Ex office.

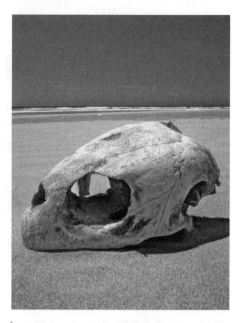

Loggerhead skull on beach.

On our first morning in Baja, I put the lens on the camera, then headed out with J. and Alberto, our boatman, to find a sea turtle to put an ARGOS satellite transmitter on.

Alberto was a fisherman and sometimes poacher, meaning he was known to fish out of his allotted area. J. had befriended Alberto and helped him out financially by hiring him to assist with his research, while trying to educate him about the importance of conserving the turtles.

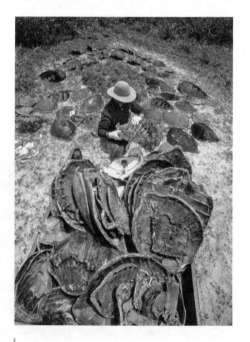

Placing carapaces in makeshift turtle graveyard.

J., along with his original project buddy, Jeff Seminoff, had started out by focusing only on researching the sea turtles. But at some point, J. realized it was more important to save the turtle population through conservation. People in Baja ate both turtle eggs and turtles, and there was little education about conserving them.

J. had two ways of dealing with the situation: One was to hire the fisherman, while teaching the locals the value of turtles to the tourism industry, as well as the value of working with people like J. and Earthwatch. But J. also needed the locals to accept and listen to him in the first place. So he took part in eating a turtle, just so he could mention it to the fisherman. As a result, the locals were more willing to listen to what he had to say, and over time he was able to get his point across.

Out on the boat, it wasn't too long before J. found a resting sea turtle. His method was to have Alberto approach the animal slowly from the back, so as not to scare it away. Then J. would jump in the water, "rodeo style," and grab onto the turtle. The whole exercise had to be done in one motion, or the turtle would get away. J. had become an expert; Alberto had tried at one point, but failed.

Once J. had the turtle in hand, we brought it aboard, and J. attached a satellite transmitter to its carapace. We were ready to release the turtle back into the water but wanted to photograph it first. So we decided to move closer to shore to protected waters, where the ocean was not so rough.

It was then that we saw a military boat heading in our direction. Alberto told us we should release the turtle immediately because these guys were always harassing him. J. pointed out that he had the authority to do his research on the turtles, and that he could show the papers to prove it. Alberto responded that these guys, being military, didn't really

care about that kind of stuff, and that they could easily stop what we were doing and make us get rid of the sea turtle.

It was a scramble for me to get my gear on; I needed to get into the water first, after scanning for sharks, which sometimes follow slow-moving boats. J. threw me a life jacket, which I was able to float in front of me and rest my land camera on.

I took a bunch of images of J. and Alberto holding the turtle before they released it off the side of the boat. Then I quickly switched cameras as J. entered the water. Alberto handed the turtle to J., and I started taking a few underwater shots of him and the loggerhead turtle with its satellite transmitter. The 12mm lens turned out to be perfect: I was inches from J. and the turtle, and it was such a wide-angle lens that I actually had to be careful not to get my head or fins in the photo.

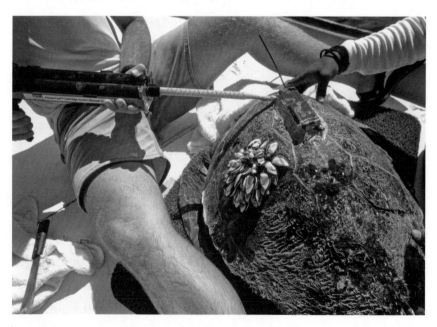

Attaching satellite transmitter to loggerhead.

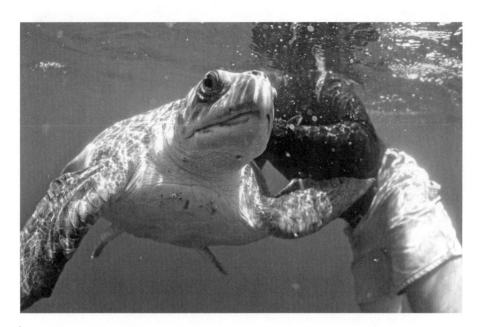

J. releases tagged sea turtle.

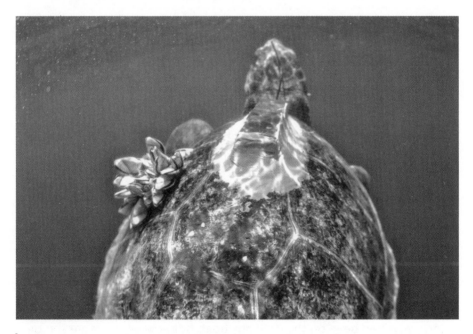

Satellite transmitter in place for tracking.

*Stories to tell: J. (center back) with (from left) Alberto "Serrucho"
Ojeda, Sabina Widman, Salvador Garcia with wife and child,
Eliza Smith Steinmeier, and Juan Manotas Gonzalez.*

We got back into the boat just as the military boat arrived. The soldiers started giving Alberto a hard time, telling him it wasn't legal for his boat to have such large engines (engines he was clearly using to outrun the authorities). The soldiers were pretty young, weren't wearing shoes, and were holding M16s. I remember thinking, I hope they don't step on anything sharp and accidently fire off a few rounds!

That night, a number of people in J.'s circle of local friends were hanging out, when the story came up about the military boat and Alberto's engines. One person knew the law, which he proceeded to explain to Alberto.

The next day, we were out on the ocean searching for sea turtles, when we saw a *bigger* military boat approaching. On it were some of the same guys who had been on the previous boat, but now with a more senior officer in tow.

J. and lighthouse keeper Victor De La Toba survey
Magdalena Island beach for dead sea turtles.

Sea turtle toe bones, carefully identified.

The cataloguing process.

Metal flipper tag on sea turtle, holding fast.

The senior officer started telling Alberto that he didn't have the right to have such big engines on his boat. Alberto began citing the law, which he had learned only the night before. The officer didn't respond, except to say, "Alright we're off"—and sure enough, they were. Clearly, he wasn't up on the specific laws, and Alberto was a rough-and-tumble guy who in no way looked like *he* was, but what he said sounded pretty convincing. J., Alberto, and I were laughing as soon as the officer and his guys were out of hearing range.

Tags that were found on surveys years later.

Javier, onetime turtle fisherman turned conservationist, with discovery: Japanese sea turtle tag.

A month later, J. and I were driving from Boston down to North Carolina, where I was to photograph loggerhead turtle bones at Duke Marine Lab in Beaufort. Along the route, we stopped in Durham to visit my cousins at Duke University. J. was a Duke graduate, so he didn't mind.

After driving part of the day and through the night, we arrived at seven the next morning and met my cousin Laura, a doctor at Duke, for breakfast, and I had grits for the first time. Then we went on to Duke to see Laura's mom at the Duke Cancer Patient Support Program she had started, as well as Laura's dad, in his office as the dean of the medical school.

From there we headed to Beaufort to meet with Melissa Snover, a researcher working with some loggerhead turtle toe bones J. had sent her. I had brought my studio lights, which I set up in the lab to help photograph Melissa and her work.

J. and I had thought about continuing straight to the Outer Banks, until we saw that the NOAA weather facility next door was already boarding up in anticipation of an approaching hurricane. They had declared an emergency, so there was only one-way travel allowed—off the islands.

We headed north to Washington, DC, finally arriving around seven in the evening. We hadn't slept in thirty-one hours, and on our long drives we had a lot of discussions. One such discussion was a recurring theme for me, one I'd been talking with J. about for a year: how magazine editors were always saying they couldn't pay for the use of my photos, but would merely give me a photo credit.

It was always frustrating for me to travel to all these remote places, paying for cameras, flights, rental cars, film, and processing, then edit, scan, caption, and put all the photos online, but not get paid for any of the work or the time I put into it. Magazines got away with these

practices for years with so many freelance photographers. But I had started to realize that if the editors wanted to use my work, it must have some value.

Since J. and I had a meeting planned at National Geographic the following day, he asked me, hypothetically, what I would say if NG wanted to run a photo of mine on the cover of their magazine, not for pay, but for a photo credit.

"Absolutely not, because if NG thought my photo was good enough to be on the cover, obviously it would have some value," I said. With *National Geographic* being such a prestigious publication, I'm sure many photographers would have said yes, but I had been dealing with the situation too long to play that game.

The next morning, J. and I went to the NG office and met with Susan McElhinney, an editor who had done a story on J. and had used a couple of my pictures in *National Geographic World*, their kids' magazine. She agreed to have lunch with us and told me that someone in the internet online department (which was tiny at the time, since the magazine's online presence was new) wanted to meet with me. So J. and I were shown to a small cubicle with two people in it, where J. sat down just to listen.

The online editors told me they'd seen my photo of J. with the sea turtle underwater in Baja, and they wanted to use it on the front page of their web edition that day.

"OK, what do you pay for usage on the web?" I asked.

"We'll give you [*X amount*] for it," one of the editors said.

I told them I thought that was fair. J. gave me a look as if to say: Did we not just have this conversation?

Location: http://www.ngnews.com/news/2000/01/01182000/loggerheads_8970.asp

nationalgeographic.com/ NEWS — Tuesday, January 18, 2000

Scientists Track Turtle's Pacific Crossing

NGNews Home
Today's Story
Archive
Search
Toolbox
Instant Delivery

Click here!

First Finds and Special Reports

Press Releases and Events

national geographic .com

enn.com

Photograph by David M. Barron/ Oxygen Group Photography

Male loggerhead sea turtles spend their entire lives in the water; females come ashore briefly three to five times during the nesting season.

By Hillary Mayell

Yamulet is halfway home. A loggerhead sea turtle, she is voyaging nearly 6,000 miles (9,700 kilometers) from feeding grounds in Baja California, Mexico, to nesting grounds in Japan.

Her journey, which began late in June 1999, marks the first time scientists have been able to track a wild adult across the Pacific. Pinpointing the route is key to protecting the species, says Wallace J. Nichols, a researcher at the University of Arizona.

PUTTING THE PIECES TOGETHER

Scientists have long puzzled over where loggerheads feeding along the Pacific coast were hatching, since no nesting grounds had been documented in the area. In 1995 genetic evidence provided the first piece of the puzzle, connecting the Baja loggerheads with hatchlings

Related Stories:
- Loggerhead Sea Turtles Go the Distance
- Half of World's Turtles Face Extinction, Scientists Say
- Conservation Tag — You're It
- 4 Young Sea Turtles Leave the 'Nest'

Related Links:
- Turtles in Trouble, National Geographic World
- Yam/ut
- The Remarkable Journey of Adelita, the Loggerhead Sea Turtle
- Turtle Trax
- seaturtle.org
- Sea Turtle Satellite Tracking

"Confirming the migration pattern and establishing the general routes taken

> My underwater photo of J. and sea turtle, featured
> on National Geographic webpage.

It may have been a million miles from being the *print* cover of a *National Geographic* magazine, but it did seem that my making the decision (and going through all the rigmarole) to get a 12mm wide-angle lens at the last minute had turned out to be worth every penny.

Keiko the killer whale side-breaches in heavy rains, Vestmannaeyjar, Iceland.

CHAPTER TWENTY
A VISIT TO NATIONAL GEOGRAPHIC LEADS TO KEIKO IN ICELAND

While J. Nichols and I were in Washington, DC, meeting with Susan McElhinney, the photo editor of *National Geographic World* (now called *National Geographic Kids*), I asked whether she generally used *National Geographic* photographers to take images for her stories in the kids' magazine, or if she had her own staff photographers. She told me she didn't usually use *NG* photographers, and since her magazine didn't have a staff photographer, most photos were taken by freelancers.

"If you're ever interested in having a staff photographer, I'd love to do that," I told her. Susan laughed.

"I'm serious," I said.

"I know you are."

After we finished lunch, she invited me to come by so she could take a look at my work. As we talked, she asked about my website and started perusing the images. She hadn't realized I'd worked on so many projects and suggested that I submit a proposal to do a story for the kids' magazine.

I was kind of excited that she thought I could do a story for *National Geographic World.* They were thinking about running a piece on elephant

seals, and Susan suggested that I research that possibility and add a few other ideas.

J. called to see if we were finished with our meeting, and Susan said into the phone, "Can I borrow him for a little longer?" It was nice to hear that she wasn't trying to get rid of me!

When I got home, I start researching stories to present to Susan. It turned out J. knew someone named Jen Schorr who worked with elephant seals in Año Nuevo State Park in California. I called Jen, and she said she wasn't doing that work anymore, but that she did have access to Keiko the killer whale, in Iceland.

I was excited to hear that, because I had always wanted to photograph Keiko, the animal from the *Free Willy* movie. When I inquired further, I was told by an Ocean Futures representative from the project that I could come to Iceland and photograph Keiko, whether or not I did a story for *National Geographic World*.

I ended up sending *NG* a proposal for three projects: one on elephant seals, one on black bears, and one on Keiko. Susan said the magazine was no longer planning to run an elephant seal story, but wondered what the Keiko idea was about and thought it sounded really interesting. We talked about it a bit, and she decided to present the idea to her boss.

After meeting with him, Susan called me and said, "There's good news and bad news. The good news is that they want to do the story. The bad news is they want to pay you for the pictures after you come back." This meant the magazine wouldn't send me on the assignment, per se, but would buy some images individually when I returned. And *that* meant they wouldn't pay for the flight, expenses, or a per diem.

"I'm not going to do that," I said.

Susan was cool. She knew that her boss was trying to save money. I told her I didn't think it was right, and she understood. I could tell she agreed with me without her having to say so.

"Tell him if he wants to send me, that would be great, and if he doesn't that's fine too, but I won't sell the pictures to *National Geographic World* when I return."

"OK, I'll tell him," Susan said.

I hung up the phone and thought, "What did I just do?" I couldn't believe I'd just played hard ball with the most prestigious, widely read, and revered magazine there is! I had never been sent anywhere by a magazine with paid expenses and a per diem. This would have been a first.

I was so freaked out about what had happened that I left the house and went to talk to friends at the photo store I frequented. When I finally came home, there were three messages on my machine from Susan.

"Hi, this is Susan, give me a call."

"Hi, this is Susan again."

"Hey, did I lose you?"

Nervously, I called her back.

"OK, he'll send you," she said.

I was thrilled, but managed to keep my cool, saying only, "OK, that sounds good." After talking through some details and ending the call, I literally screamed.

A few months later, I arrived at the Westman Islands in Iceland after not sleeping for over twenty-four hours. The first thing I did was find a place

to stay, as I hadn't booked anything. Luckily it was February, which is off-season—if it had been summer it would have been a problem.

I decided to call the people working with Keiko just to let them know that I had arrived, then get some sleep.

"OK," they said. "We'll come pick you up in twenty minutes."

"Well," I said to myself, "just take advantage of the situation and get your gear together and head out to the pen."

Ocean Futures boat, Klettsvík Bay.

The researchers used hard-shell Zodiac-type boats to take me to the pen, which was situated in Klettsvík Bay. Because the ocean temperature was so cold, you had to wear a survival suit in case you fell in the water. Around the pen was a ringed barrier made out of floats and netting. To get by it, there was a "gate" of sorts made of some rolling buoys that you could drive the boat across.

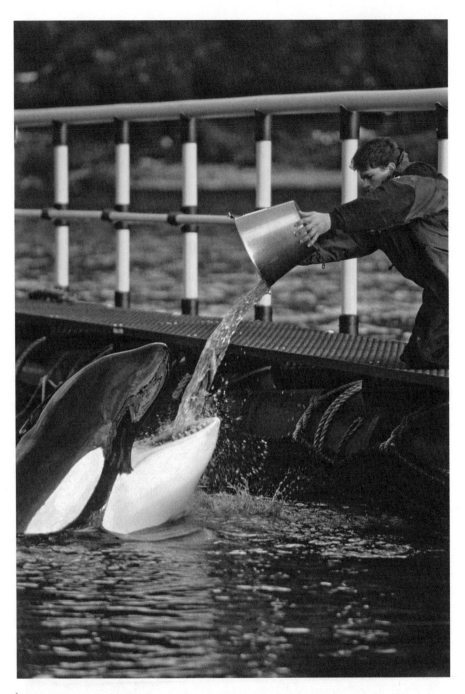

Mark Simmons, director of the Animal Behavior Team, feeds Keiko.

It was gorgeous, with cliffs and ocean waters all around. The first day I arrived it was clear, then it started snowing, then sleeting, and finally was clear again. It was great to be able to capture all the different weather visuals in my photographs.

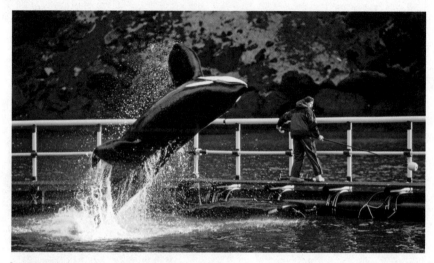

Side-breaching near his trainer Mark.

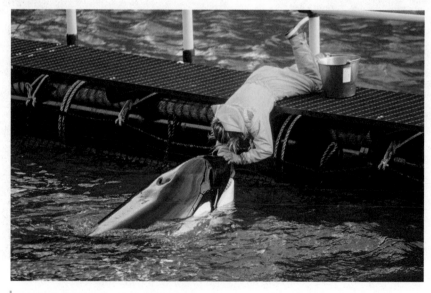

Kelly Reed checks Keiko's teeth.

Weathering a storm: bay pen in Klettsvik Bay.

I ended up photographing Keiko for three or four days on Vestmannaeyjar Island off Iceland, on Klettsvík Bay. Photographers typically aren't allowed to stay there that long, but I was granted an exception, in part because I'd done a number of research projects and knew both not to get in the researchers' way and how to anticipate what they needed as I did my job.

One example was when the researchers were trying to get Keiko to go from point A to point B. It was important to ensure there was good communication between the researchers and Keiko when he was in the open ocean, so they were practicing different commands.

I was preparing to photograph from the other side of the pen when the researchers told me that Keiko was very curious, and that he would probably come to me before going to point B. They wanted to keep him from interacting with any more people than was necessary, so that he didn't do something similar in the wild.

The researchers told me that if Keiko did come over to me, I should just ignore him, but to continue doing what I was doing and not freeze, so he didn't get the idea I was changing my behavior because of his presence.

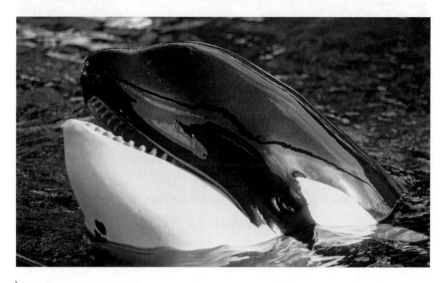

A quick study: Keiko learns A to B behavior—moving from one point to another.

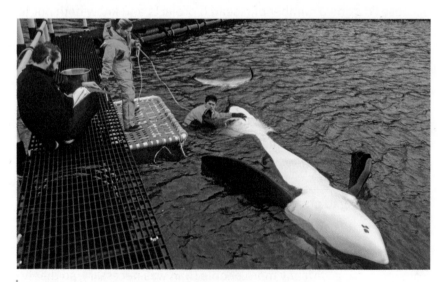

Mark (right) performs morph metrics with Keiko as (from left) Stephen Claussen and Kelly Reed look on.

Because Keiko's pen was in the actual ocean and not a pool, I couldn't see him below the water until he was upon me. His head came up out of the water right in front of me as I was kneeling on the walkway. It was amazing, but I didn't react and just kept working with my cameras. After thirty seconds or so, Keiko slipped back into the water and made his way to point B.

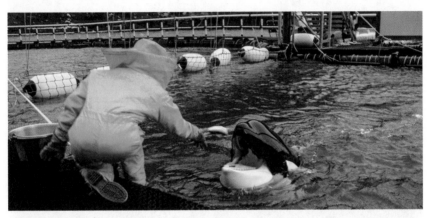

Kelly feeds Keiko in bay pen.

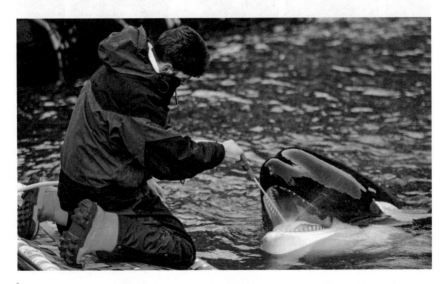

Getting a refreshing water spray from Mark.

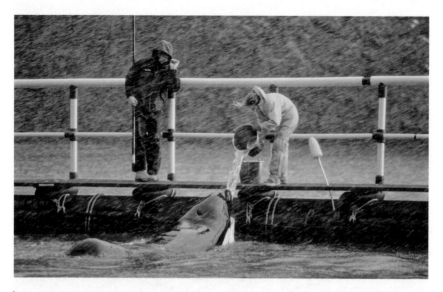

In wind-driven rain, Mark (left) and Kelly feed their charge.

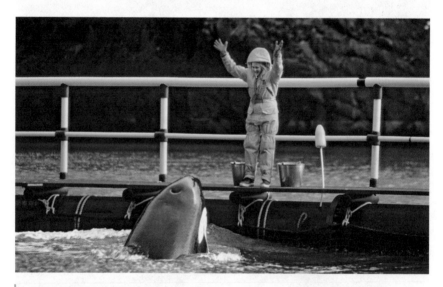

Kelly gives Keiko instructions, using hand signals and whistle.

I was told a day or two later that this was the reason I was still there. The researchers knew I respected what they were doing and did nothing to disrupt their work. They said most photographers were so disruptive they were there for only one day.

Keiko's feed bucket, full of herring.

At the end of my first day I was seriously looking forward to sleeping, but it turned out people had other plans for me. The head of security for the pen, Smari Hardarson had recently been named "Mr. Iceland"—a big guy that you didn't want to mess with. He said he was having some folks who worked on Keiko's pen over to his house for dinner, and I needed to come and meet his wife, Lena, and family.

After dinner, he told me a group of guys were going out, and I had to come with them.

"OK," I said. "For one beer."

At the restaurant bar, a young woman came up to me and said hi. I got the idea pretty quickly that the guys knew her, and that she was a bit odd. She apparently honed in on me because I was new to the town. She asked if I would go home with her.

"Well, I'm kind of busy with my friends here," I said. "But thank you for asking."

Then she asked where I was from, and I told her I was from Boston.

She said she'd just received a business card from somebody from Boston, which she handed to me. It belonged to a woman who worked at the Worcester Art Museum. I thought, that's weird—*I* worked for the Worcester Art Museum, as a freelance photographer. As a matter of fact, I'd been asked to take photos at an event there that very night, but had told them I'd be in Iceland. I thought I must have dropped the card out of my wallet by accident, but I didn't recognize the name of the person whose card it was.

The young woman told me she'd gotten the card from someone who was sitting at a table on the other side of the restaurant.

I walked over to the table, thinking, "This girl is making this up, but what's with the card?" The woman I approached at the table was a bit stand-offish, perhaps because she had noticed that the first young woman was a bit off.

"Is this your business card?" I asked.

When she said yes, I told her I did freelance photo work for the museum and would have been taking photos there that very night.

"You're kidding," she said. "What's your name?" When I told her, she said, "I've worked on your photos."

What a coincidence—we weren't in Iceland's capitol, Reykjavik, but on an island off the coast, at the same restaurant at the same time, and this nutty person had connected us. And I'd been scheduled to take photos at the museum this woman worked for, that night.

Two hours later, the guys and I were headed to a club, as the restaurant was just a hangout before the party. A few people had bailed on the rest

of us, but I somehow stuck it out until three or four in the morning. I was beyond sleep deprived, and the guys were impressed that I could make it through the night without passing out!

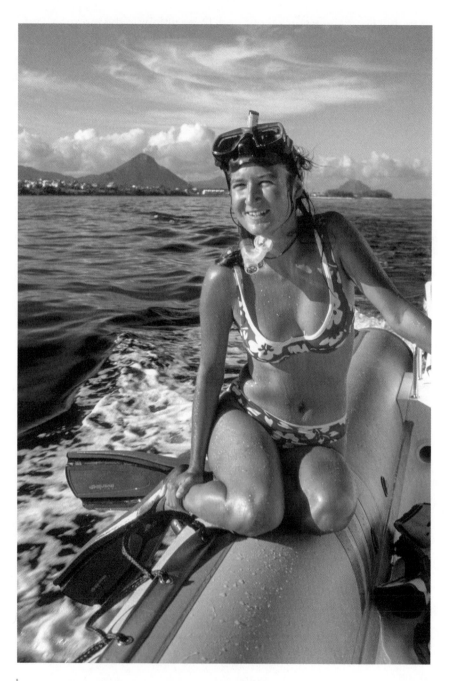

Principal investigator Delphine Legay, just back from swimming with dolphins.

CHAPTER TWENTY-ONE

FROM AN EARTHWATCH CONFERENCE TO SWIMMING WITH SPERM WHALES IN MAURITIUS

It was November 2000, and I was attending an Earthwatch conference in Cambridge, Massachusetts. The goal of the conference was to connect researchers—or principal investigators (PIs)—with potential volunteers.

Along with presentations by the researchers showcasing their projects, the conference included a "poster session," in which researchers would stand beside posters featuring some photos, text, and data, and volunteers would have a chance to talk to them one-on-one while deciding which project they'd like to go on. This set-up allowed volunteers to get to know the researchers and their subjects in a more personal setting than a group session.

As I checked out the posters, I came across a project on whales and dolphins in Mauritius. I thought to myself, "That would be a cool place to go, but it's a long way to go to photograph dorsal fins." Then I noticed that the researcher had posted pictures of dolphins and whales taken underwater, and I thought, "Wow, she's obviously got permission to do

that—I wonder if I could too?" I saw that her first name was Delphine, which struck me as an appropriate name for a dolphin researcher.

I found the researcher, Delphine Legay, to let her know I was interested in her project, and to ask if I would be able to get in the water with dolphins and whales.

"Yes, you can do that," she said.

"Don't you need special permission?" I asked.

"Well I'm the only one working with dolphins and whales in Mauritius, so I can take people along."

Apparently, in Mauritius the government knew who Delphine was and what she was doing, and they knew she had the authority to be in the water around dolphins and whales. The situation is different in the United States, where there's an authority that doesn't allow you to approach animals without a permit.

"OK," I said. "I'd like to come to your project, when do you start?"

"The first project is in March."

"Great, I'll be there in March."

"OK!"

About an hour later, I saw Delphine again.

"I'm serious about coming to your project in March," I said.

"I know you are."

A while later, I saw Delphine with Lotus Vermeer, a former turtle researcher I had befriended at Earthwatch, and another researcher,

Suzanne Dorsey, who worked with damsel fish. Each of them was smart, fun, beautiful, energetic, and independent, and I was drawn to all three.

Add to that researchers such as J. Nichols, Jeff Seminoff, and John Frisch, who also shared a live-life-to-the-fullest quality, and Earthwatch was filled with people who had an "I can do anything" way about them and a desire to learn about our planet and share that with others. It was infectious to be around.

After Delphine was back in Mauritius, I got in touch with her to shore up the details of my visit. She said she had a cot I could sleep on, in a big room where they stored all the diving gear and so on, and she was happy to have me on the project.

I contacted Earthwatch as I usually did, to let them know what projects I was hoping to visit, including Delphine's "Whales and Dolphins of Mauritius." The response from Earthwatch was that I couldn't go on Delphine's project because the researcher said she didn't have room for me.

Earthwatch had no idea I had already been in contact with Delphine, so I relayed what she had said to me: that it was OK to come on the project, and I had a place to sleep. After some back-and-forth and clearing up a few misunderstandings (among other things, Earthwatch was concerned about putting extra stress on Delphine, because it was her first team with volunteers) I finally got the all-clear to go to Mauritius.

Mauritius is idyllic in so many ways, with its scenic mountains, beaches, and beautiful, clear waters encompassing the island. While taking in the beauty, we spent much of our time on hard-shell Zodiac-type boats with two large outboard engines.

At times, we'd be with spinner dolphins in Tamarin Bay, where I was able to get in the water and hold onto a handle and rope attached to

the front of the boat. Usually I'd be on the right side of the boat, and as we moved, spinner dolphins would sometimes come pretty close, close enough to photograph them.

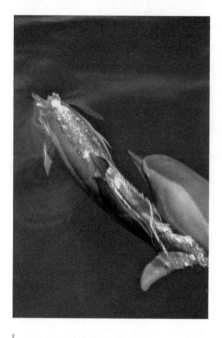

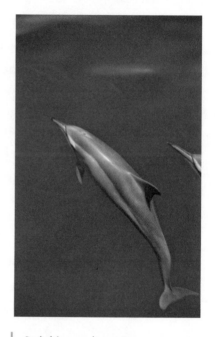

Spinner dolphins break water's surface.

Dolphins underwater, photographed from boat.

Mauritius is in the Indian Ocean, which drops off to about twelve thousand feet deep not too far offshore. It was there we'd go looking for sperm whales, since it was the time of year when they'd normally show up in these waters.

Just to clarify, a sperm whale is not technically a whale—it's a toothed animal that uses its teeth to hunt, and it has its own classification. In French—one language spoken in Mauritius—the sperm whale is called *cachalot*. (What we commonly refer to as whales are actually baleen whales, which feed by a system in which baleen hair, attached to the baleen plate of the jawbone, filters krill out of the water.)

Earthwatch team observes dolphins.

We hadn't seen any sperm whales on our searches so far, and it looked as if the Earthwatch team might not see any this time. Then, on the very last day the team would be there, we went out looking for sperm whales with Delphine's friend Nilakanthan operating the boat, as Delphine was leading a prescheduled private tour to view dolphins.

We went out pretty far, but didn't see anything. So we started making our way back, when one of the volunteers said she'd spotted a whale blow, way out on the horizon. We were skeptical, because this particular volunteer had yet to spot *anything* on the trip. We stopped, didn't see anything, and started heading back again. Then a few of us who were checking the area that she'd pointed to finally saw it too.

We started racing toward the whale, and Nilakanthan stopped the boat to alert Delphine of the sighting. We later learned that once Delphine realized there'd been a whale sighting, she immediately ended her dolphin tour and brought her guests to shore. She had scheduled

another family, including a daughter of about eight, but asked them how they'd like to see sperm whales instead of dolphins, and luckily they were happy to change course.

Delphine films underwater.

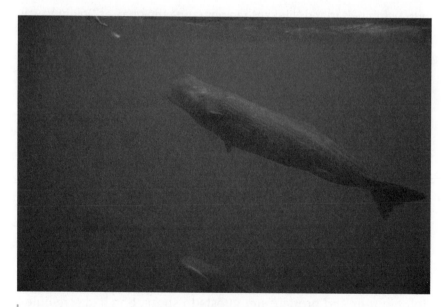

Delphine (barely visible, upper left) with sperm whales.

We approached the whales and saw four or so that had surfaced. Over the next minute or two, others surfaced, making for twelve sperm whales in all. The whales had likely been hunting, since they were now resting on the surface of the water. When hunting, sperm whale dives can last as long as an hour and a half, going down to a depth of some ten thousand feet. These whales usually hunt for small to medium-sized squid, and sometimes even larger ones up to sixty feet long.

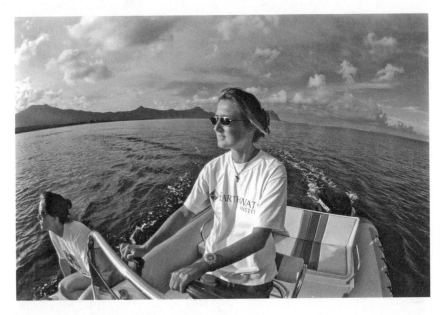

Delphine at the rudder.

After we took a few pictures from the boat, everybody scrambled to put on their snorkel gear and get in the water. I had never been in the water with whales before, so this was spectacular. Among the mix of whales, there was a baby sperm whale that started swimming toward us, but the mother corralled it as if to say, "No, no, you're not going over to them."

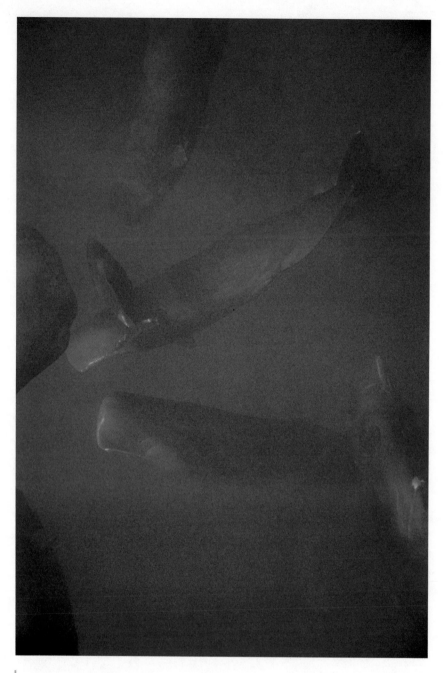

Six sperm whales with baby.

PULLING A WHALE

Filming the whales: Delphine.

The adult whales were a bit protective of the little one, so they all moved off after a short time. We turned to go back, only to realize that nobody had stayed with the boat! That's big no-no in the marine world, especially if a boat isn't anchored. It took us a bit of a swim to get back to it.

We encountered the whales once more, this time with Delphine and the family she'd taken with her, and were able to spend some more time in the water with these majestic animals. The eight-year-old daughter got in the water with the sperm whales as well. I told her for someone her age to witness what we were seeing was amazing: "Wait until your friends hear about this!"

I remember marveling that Delphine could spend so long underwater without taking a breath, because she'd been free-diving for so long. She could be underwater for four or five minutes without having to come up for a breath. As for me, I'd go down, take a few pictures, come up, go down, maybe three or four times before Delphine would start to make her way up.

Given the snafus I encountered at the beginning of the trip, it's almost a miracle that I was able to go at all, but I'm forever thankful that I did. Tragically, Delphine drowned during a free dive a few months after I was there. Had I not been allowed to go to Mauritius, I would never have hung out with her, or photographed her, or fallen for her.

Scanning the waters: Delphine (left) and assistant Nilakanthan.

Cheers! With (from left) Martha, Joanne, Nilakanthan, Janice, and Delphine.

Delphine and Nilakanthan sing their hearts out.

Fun after hours (from left): Delphine and Nilakanthan with Earthwatch volunteers Janice, Joanne, and Martha.

Etched in memory: with Delphine, last day of project.

Because of the time Delphine and I spent together, I was able to bring her mom, Geneviève, some beautiful large print images of her daughter when I took a trip back to Mauritius through Paris that November. I met up with Geneviève in Paris, along with Janice, a volunteer who had been on the same Earthwatch team and would return to Mauritius along with me.

When Geneviève spoke, you could close your eyes and hear Delphine's voice. She seemed like an older version of her daughter in appearance, personality, and mannerisms. Whereas Geneviève had grown up in Mauritius then moved to France, Delphine had grown up in Paris, gone to the Sorbonne, then moved to Mauritius. To this day, twenty years later, I'm still in contact with Geneviève.

Making the journey from seeing Delphine's poster at Earthwatch to being in the water with sperm whales was not all that difficult. It was just a matter of making the decision, then following through on the logistics of arranging the trip. As a result, I will ever be grateful to have known Delphine, and her mom.

Delphine ascends from free dive some hundred feet down.

Principal investigator John Cox radio-tracks elk.

CHAPTER TWENTY-TWO
ELK, COYOTES, AND A POSSUM SURPRISE IN ROBINSON FOREST, KENTUCKY

In 2001, I had the opportunity to travel to a remote part of Kentucky to take photos for an Earthwatch project on elks, led by a researcher named John Cox. The plan was for me to come to the site before the first volunteers joined the project.

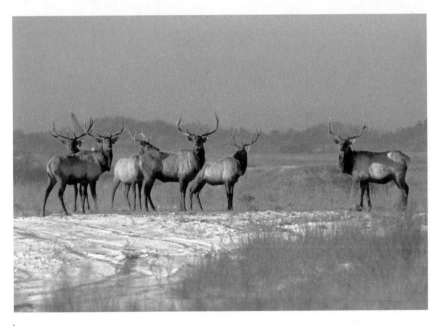

Majestic site: group of elk.

Because eastern elk had been wiped out by 1877, western elk had been brought in to reestablish the elk population, which was living mostly on coal strip mines. The elk were doing OK on the strip mines, but the remnants of the strip mining were pretty ugly. Many of the mining companies had decided to pay fines rather than replant trees, as it was much cheaper. It was infuriating to me that the government's policy allowed for this loophole.

Some of the elk were radio-collared, so we did a lot of radio tracking to try to find their locations—not easy to do in the wooded hills because the signals were bouncing in many directions. One alternative was to radio track from a small plane, which could cover a large area easily.

Elk radio collar for tracking.

John and I went to the airport to meet up with the pilot who would fly us. After John registered which pilot it was, he offered a word of warning to me: "It's going to be rough flight!"

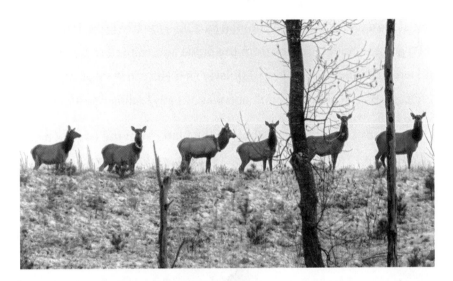

Elk line up on hillside.

John uses compass to compare to radio signal.

He explained that this pilot had a way of flying that tended to make people sick. He was right, and after half an hour I was already feeling the effects of the erratic flight as we wove through the hilly region, up

one slope and down another, not too far above the tree tops. John asked if I'd gotten enough photos from the plane and wanted to be dropped off while he finished tracking. I quickly said yes, since I was hoping to photograph the plane in flight, and was already feeling nauseous.

I was able to get some good shots of the plane from the edge of a cliff next to the runway. The runway was at the top of a mountain, so when the plane made its approach it was almost level with me, and the view was fantastic.

Radio-tracking device, mounted on airplane.

Mining pits from above.

Radio-tracking in process.

My suitcase had not made the flight from Boston for some reason. It didn't arrive for the first three days I was there. The airline baggage-

Approaching the runway.

delivery people apparently had a hard time finding our cabin in Robinson Forest in the middle of nowhere in southeastern Kentucky. They had gone all the way across the state, west to east and then north to south. They got it on their third try!

In the meantime, I had to borrow some of John's clothing, including a camouflage coat. It seemed like everyone down there wore camouflage.

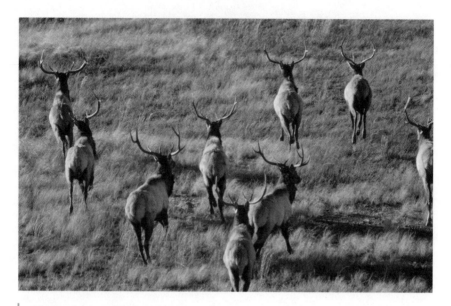

Elk head across the grasslands.

This area of Kentucky was the poorest place I'd ever been in the United States, and the manifestation of poverty could be seen everywhere. The homes were rough and clearly run down. Everywhere we went, the effects of poor health and dental care were apparent—it seemed as though everyone we saw had some sort of health issue they were contending with.

John had been living in Louisville, in western Kentucky, and though he had an accent, I was able to understand it perfectly. It was interesting to listen to him speak to the maintenance people at the forest and put on a heavier accent to make them feel like he was one of them.

It took me a while before I could understand what these guys were saying. When one of the workers mentioned his weekend activities—"I was huntin', and I was down there and shot myself a deer, right between the eyes"—in that heaviest of drawls, I could just barely make out what he said.

Toward the end of my visit to the elk project, John asked me to come back in a month or so, when he'd be working on another project, this one on coyotes. On my return, I decided to bring my own camouflage. I had a really cool desert camouflage jacket from the Israel military, and I figured I'd be the only one wearing that type of jacket. And sure enough, as I was walking into Walmart, John eagerly said to me after some guy passed by, "Did you see that? He was checking out your camouflage!"

"Yeah I saw that!" I said, smiling.

As we started to work on some traps for the coyotes, John informed me that coyotes are the most successful animal in North America, with their ability to live anywhere, including urban areas. He told me they're incredibly smart and very stealthy—for example, they'd never approach a carcass from an easy direction, for fear it was some sort of trap.

Gentle touch: John holding sparrow.

Bobcat tracks frozen in ice.

The traps John used were modified leg traps, so he could ensure they didn't break the animals' legs or compromise their ability to survive after being released following a health workup. Once the traps were set, John covered each one with wood, dirt, and leaves.

We started to collect road kill to help attract coyotes to the traps, and asked people to let us know if they had a dead animal we could use. We amassed a lot of road kill in the back of the truck, and it was smelling pretty bad.

We also had, inside a large black trash bag, the head of a bison. When John had gone out west to collect elk, he'd come across the dead bison. He wanted to bring it back to Kentucky so he could keep the bison's skull once it had decomposed. We got used to the smell (to a degree) after three or four days of driving around. But on our next visit to Walmart, we heard gasps and comments like, "My God! What is that smell?" each time a person walked near our truck.

By my final day on the project, we hadn't caught any coyotes at any of the sites, and I was desperately hoping we'd catch one. Finally, at the last site, on the last day, we caught not just one, but two.

We headed up the hill to the first trap, and John asked me if I could carry one coyote down. So, after taking some photos, and after John had anesthetized both animals, we each took one down to level ground. John weighed each coyote and checked for any visible issues or cuts, then took an assessment of its general health before setting it free. One coyote had a lot of blood on it, and it turned out it was a female in estrus. As John finished checking the animals, it had started to snow and gotten pretty cold.

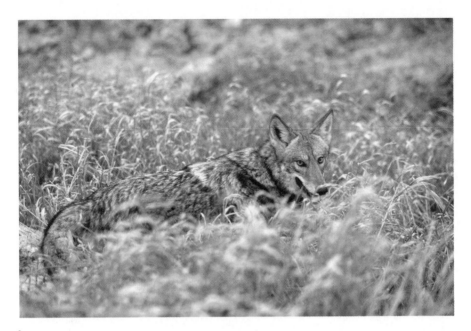

Coyote in modified (safe) leg trap on hillside.

Just before John administers sleeping agent.

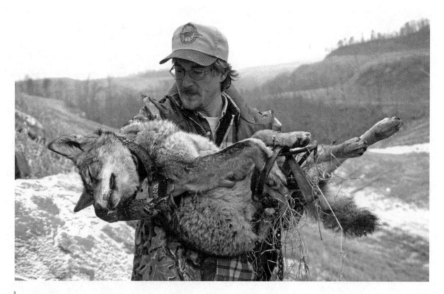

John brings anesthetized coyote to be examined.
Modified leg traps prevent harm to the animal.

It was time to leave, so John gave the coyotes a reversal drug. The animals got up and walked away, if not very steadily for the first fifty feet or so.

John had some grad students working on his project who were scheduled to arrive at the cabin for the weekend. They were making a long drive from Louisville, so we decided to prepare dinner for all of us.

I had an idea for how to play a joke on them. In collecting the road kill to attract coyotes, we'd been given a dead possum. What if we pretended to serve the possum as part of our dinner?

I made sure the place smelled great for when the students walked in—roasted vegetables, pasta, chicken. Meanwhile, I took a big tray and put a few roasted vegetables on it, just enough to make it look like it had been cooking in the oven. As the students drove up, I put the tray in the oven, with the untouched hairy possum on top.

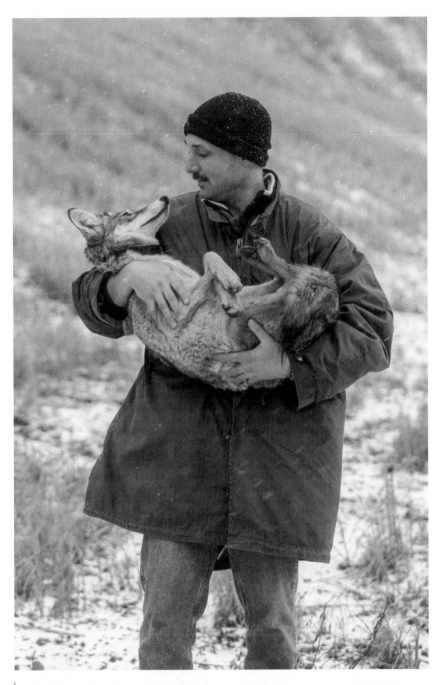

Carrying a coyote: my chance to see one up close.
Note blood is from estrus, not injury.

The students walked into the cabin, and just as I had hoped, started to exclaim, "It smells amazing, can't wait to eat!"

"Yes, sit, let's eat!" John said, and they all found a seat at the table.

I opened the oven and took out the tray using the oven mitts (even though the tray was cold), and John shut the oven door behind me as I placed the tray on the table. The students looked startled, and a bit confused.

My tempting opossum dinner for unsuspecting visitors.

Without breaking a smile, John and I sat down. Acting normally, he asked everyone what they would like to drink.

"Are you supposed to cook it like that?" someone blurted out.

It took ten or fifteen seconds before John and I started laughing, and then there was a sigh of relief from at least a few worried students who'd been wondering if they were expected to eat the hairy possum!

African penguin snug in culvert.

CHAPTER TWENTY-THREE
HUMAN RIGHTS DAY ON ROBBEN ISLAND, SOUTH AFRICA

Most Earthwatch projects (though not all) are set in natural and often beautiful places. Each has its unique wonders, perhaps because of the animal or subject studied, or the surrounding flora and fauna. Some even have historical significance. The South African penguin research project on Robben Island had all of that and more.

The penguin colonies were a treat to visit and photograph, though I initially wondered what animals I was hearing when I went out to see them for the first time. As I walked with Philip Whittington, the researcher, and the Earthwatch volunteers, I was sure I heard donkeys, which surprised me. But I was assured that, no, it was just the sound these penguins make. Because of that, they were called jackass penguins, though over time the preferred name has become "African penguins."

Robben Island African penguin colony.

African penguins at Boulders Beach, Simon's Town.

Parent warming its chick.

Making a vivid pattern along the shore.

Marking an African penguin, Robben Island.

Tread carefully: African penguin egg.

Wandering past beachgoers, Boulders Beach, Simon's Town.

BBC filmmaker Justin Maguire with his subjects, Boulders Beach.

The political and historical significance of Robben Island, a small island off the coast of Cape Town, is powerful. Once home to seals and penguins, birds and tortoises, the island was settled by the Dutch over 370 years ago and used as a prison, first by the Dutch and then by the British. Nelson Mandela spent eighteen years of his twenty-seven-year sentence there, one of many political prisoners sent to the island.

The day I arrived on the penguin project happened to be Human Rights Day in South Africa. I had arrived at Robben Island early in the morning on the first ferry, which is reserved for ferry workers, island guides, and other staff. Upon meeting Philip that first morning, he told me he had some things he needed to do before we'd be going out to join the Earthwatch volunteers, who had been there for a number of days.

Philip suggested that while I was waiting for him I could join a bus tour, or walk around as I pleased. He did caution that if I walked the fields, I should watch out for the ostriches, which could be aggressive.

Keeping my distance: ostrich in fields, Robben Island.

Bonteboks, South African antelope.

The Leper Graveyard, Robben Island.

Robben Island quarry where prisoners once worked.

Nelson Mandela's former cell, Robben Island.

The tourists were typically taken in groups for three-hour tours of the island. There was no option to stay longer, or overnight. Tours visited the rock quarry where the prisoners had worked, took in a view of Cape Town, and drove by other sites on the way to the prison for a historical overview and to see Nelson Mandela's cell. At each site the tour visited, everyone got off the bus, then got back on five or ten minutes later. Because there were no assigned seats, people could sit wherever they chose.

After visiting one of the sites, two middle-aged couples got back on the bus and were approaching the row where they'd been sitting, when one of the men told a young Black man he was in their seats and needed to move. The speaker seemed to have the accent of a Dutch descendant rather than a British descendant, and his whole manner was rough. I had seen people like him in South Africa before. They reminded me of racists in the United States.

I was a little taken aback by the exchange and thought I should say something, but decided not to, since I didn't understand the country fully enough to intervene. It was one of the few such times in my life when I backed off and didn't say anything.

I noticed that the Black man also appeared to want to say something, but decided to refrain. He hesitated to move. After the Dutch man repeated his demand, the Black man got up and sat in a seat in front of me.

I leaned forward and said, "What was that all about?" He kind of shook his head, just enough for me to notice, without making a scene. Of all days to see this, Human Rights Day.

Later on, I was walking in the fields and came upon a dead kudu (a large species of antelope). I saw two women walking toward the area and went over to them to see what they were up to. They were residents of the island, headed out to fill up the trough with water from the water tank for the animals.

I told them about the kudu, and they asked me to show them where it was, since they kept track of them. After showing them, I accompanied them to the water tank, then we all went back to town and decided to meet up for dinner a little later.

At dinner, one of the women, Ruth Carneson, told me about her sister, who had written a book about her parents, who were human rights activists. The parents had been imprisoned because of their activism, though not on Robben Island, because they were white. The book, *Homage to Hope*, had been published in England.

As we were talking, one of the women said hello to a man who was walking through the restaurant toward the kitchen in the back. It was the young Black man who had been asked to change his seat on the bus.

I told the women what had happened earlier and asked if they would talk to him to see what he had to say about it.

I learned that the man, whose name was Jerry, confirmed that the incident had happened. He'd apparently wanted to say something to the tourists, but was on the bus as part of his training to become a tour guide and knew it would not be good to get into an argument with tourists when he was training for that job.

"But I thought the tour guides were mostly former prisoners," I said to the women. They told me that Jerry *was* a former prisoner. "But he's so young," I said, surprised. The woman told me he was in his early thirties and had been imprisoned when he was quite young.

These tourists were visiting Robben Island to see the prison and possibly learn something about its history in the context of apartheid, and they treated a Black man, a former prisoner of that prison, in this manner on Human Rights Day. If you had written this scene into a movie, people would say it was contrived.

I was disgusted by what had transpired on the bus. Had I known about Jerry's being a former prisoner, I definitely would have spoken up.

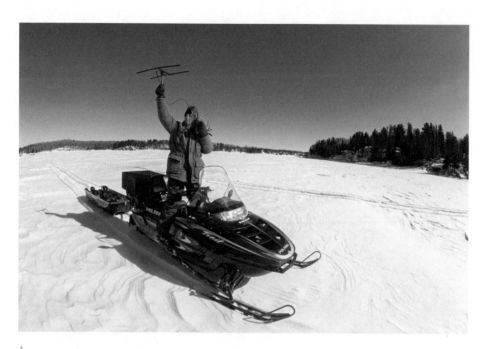

Principal investigator Kristina (Kris) Timmerman uses radio telemetry to locate black bears.

CHAPTER TWENTY-FOUR
WHEN BLACK BEARS AND SEA TURTLES LEAD TO FURTHER TRIPS

When you embark on a trip to somewhere, your expectations are generally simple: you'll go to a place, enjoy your time, and come home with great memories and possibly some great photos. What you might not realize setting out—and what I've consistently found—is that one trip can often lead to another, perhaps because you like the idea of doing more traveling, or because you meet people who speak of their past or future travels and inspire you to plan another trip.

White-out at Voyageurs National Park necessitates a down day.

During my years of photographing Earthwatch projects, I would more often than not be asked to return to photograph another aspect of someone's research. I've found that if you're engaging, and the researcher likes having you around—because you possibly *add* to the project rather than hinder it—there's a likelihood you'll be welcomed back.

Here are a few examples of times when a trip I took led to one or more additional expeditions.

In the spring of 1998, I went on an Earthwatch black bear project in Minnesota with researcher Kristina Timmerman. Kris was trapping bears in large tubes so she could monitor their health. First, she'd give the bear a sleeping agent, as well as a drug that would fog its recent memory so it wouldn't associate this traumatic event with humans.

Kris would weigh the bear with our help, take a blood sample, and sometimes extract a tooth so she could determine the animal's age. She'd check for wounds or oddities, such as eye infections, and treat them. She'd always tag the bear if it wasn't already tagged.

The trip had its intriguing moments. One time a bear that had been trapped and undergone a health check was lying on the ground in front of us, as we sat on a log about eight feet away. Kris had given the bear a reversal drug to wake it up. I couldn't help asking if we'd be moving farther away before that happened.

"No, the bear won't be interested in us," Kris said. "It will want to move away, because it'll be in a fog for a little bit."

I figured she knew what she was doing, and sure enough, when the bear started to wake, it just looked at us and moved away in a stupor.

Kris and park ranger John with yearlings,
Voyageurs National Park, Minnesota.

Working up black bear number five.

Examining some formidable teeth.

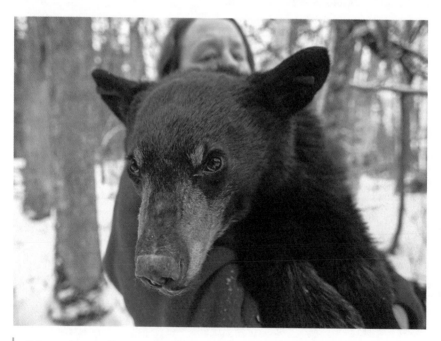

Kris carries yearling number fifty-six.

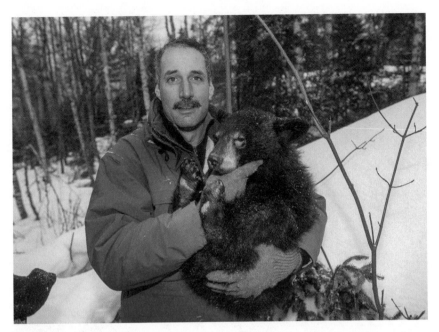

My opportunity to hold a black bear yearling.

Unexpected stop: National Park plane lands to ferry Kris to hospital.

Kris's hand after unlucky encounter.

Powerful jaws: x-ray shows broken bone.

Kris had an infectious personality, and she loved the work she did. She worked with bears and had no fear. Well, no fear of bears, anyway! The two of us got along really well, and she suggested that I think about returning in the winter to photograph a different aspect of her project, when she would be checking on the bears in their dens.

It sounded like a pretty interesting thing to do, so I did return twice to photograph Kris's work on the denning bears, allowing me to see yearlings and cubs for the first time. Kris would radio-collar female bears in order to track them to their dens. Then we'd snowmobile on the lake between Canada and the United States at some fifty miles an hour, stopping to track the bears' collars as we got closer to them. We'd hike through the snow on the U.S. side to find the dens.

On the final day of my third trip, as we were tracking the last bear, Kris mentioned that this particular bear could be a bit ornery. So the park rangers and I maintained our distance from the den and kept the two-way radio on the lowest setting, while Kris tried to inject the bear with a sleeping agent. Typically we'd wait maybe ten feet away, but this time we were waiting down a hill.

I was standing next to a park ranger named John when we heard a loud whisper from another ranger on our team, who had stayed with Kris. The ranger was saying, "John . . . John . . ." and we knew something was wrong. As we made our way up the hill, we saw the other ranger helping Kris, who was holding her hand as they walked down toward us. Kris seemed to be in shock. We surmised the obvious—that she had been bitten by the ornery bear.

When bears hibernate, it's actually called semi-hibernating—they do venture out of their dens a bit, and when they're sleeping, they're not in a deep sleep. Usually, the bears face headfirst into their dens, but this one had turned around to face the opening. Kris had a hard time trying to reach around and get the syringe into her hind quarters.

We had seen a park service plane fly over and wave his wings at us earlier, when we were heading up the hill. So we radioed him to turn around and pick up Kris. The pilot took Kris off to Falls Memorial Hospital, and we drove our snowmobiles back to the trucks.

I raced to the hospital, where I found Kris in a lot of pain. I was able to photograph her X-ray, hanging up on a lightbox, as well as the open wound on her hand. The mama bear had broken a bone on Kris's hand, and the bone was completely separated. The medical staff had recommended driving down to Minneapolis for more advanced surgery, and for Kris to get treated by infectious disease experts there.

While the medical team got Kris ready for discharge, I drove back to the cabin and packed my gear, as well as some things I thought she might need. After picking her up at the hospital, we returned to the cabin for a brief check, then set off on a five-hour drive to the University of Minnesota Medical Center.

Although we arrived very late at night, the infectious disease people seemed to come out of the woodwork. They didn't see bear bites too often, so everyone wanted in on Kris's treatment. She had no lack of attention during her hospital stay! After her surgery, Kris sent me an X-ray of her repaired hand, and it looked perfect.

In 1997, I met the turtle researcher Jeff Seminoff at an Earthwatch conference and asked him about a project he was working on in Baja. I especially wanted to know whether his team worked hands-on with sea turtles. He told me they did, and said I was welcome to come photograph the project.

I went to Baja that summer, first to visit the "Baja Island Predators" project led by zoologist and scorpion expert Gary Polis, then to meet up with Jeff Seminoff on his sea turtle project only a twenty-minute drive away. One thing I will never forget is the way Jeff greeted me—something I've tried to do to this day, any time someone visits my house. Jeff came out of his *palapa*, or hut, and greeted me as though I were a close friend. His whole manner of being was to make his guests feel welcomed.

Jeff's project was just breathtaking—scenery, turtles, boat rides, hammocks, food, and company. What a treat to be lucky enough to be there, and to experience and learn in this wonderful environment. Jeff told me that his marine biologist colleague, Wallace J. Nichols (whom I had not yet met), would be arriving for the last part of my visit.

At the end of my scheduled stay, J. offered me an invitation: "We'll be going down to the other side of Baja, south of here, and you should come with us."

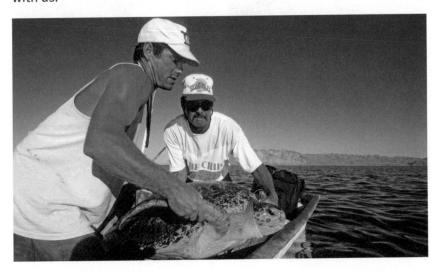

Principal investigator Jeff Seminoff (left) and assistant Yoshio Sazuki release black sea turtle in Baja.

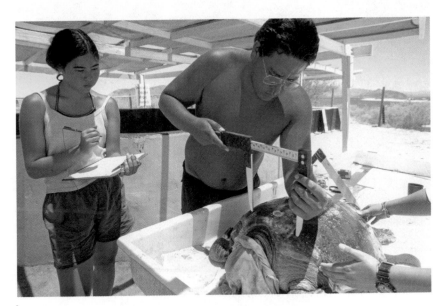

Turtle measuring: Earthwatch volunteer Marissa Kobayashi and assistant Tony Galvan at work.

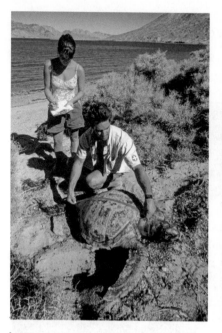

Jeff with Earthwatch staffer Rachel Nixon, measuring dead turtle.

St. Joseph Bay and beach, Florida.

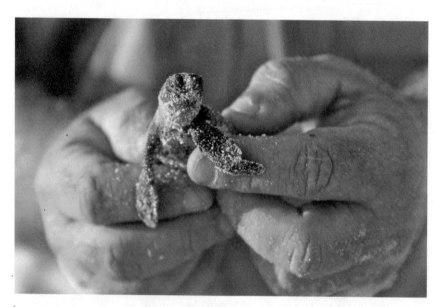

National Park Service ranger Joe holds loggerhead hatchling, St. Joseph's Bay.

*Principal investigator
Erin McMichael displays
loggerhead hatchlings.*

*On its way: hatchling
heads to the ocean.*

I didn't have much going on at home, so I was able to change my plane ticket and join them. Things expanded from there—my initial projects with Jeff and J. led to a number of future adventures, including Baja (a few more times), Florida (twice), North Carolina, Japan, and the meeting at National Geographic, which led to Iceland to photograph Keiko, the famous killer whale.

Roundabout connections, branching out from one researcher, one project to another. I've always found that if you're open to it, going to point A might lead you to point B, which just might lead to point C and beyond.

PART III
RANDOM
OPPORTUNITIES

The stories that follow are a bit of a hodgepodge: A persistent teenager's creative attempts to sneak into the Olympic Village finally pay off (kind of). An unaffiliated freelance photographer wheedles his way to the top of a national monument. An American visitor to Cambodia finds himself crossing paths with a CNN Hero, of all people—and serendipitously gains entry to a rare and unusual location. What do these stories (and the others here) have in common?

These random stories of opportunity exemplify how different such experiences can be, and how they can happen at any time in your life. Not all paths are linear, but unexpected possibilities are always out there, ready to be had. If you look at your own past notable experiences, are there common threads that run through them? Maybe the way you approached a chance that you were offered, or a path that lay in front of you, leading you in one direction or another?

We don't always analyze why we do what we do, either at the time or after the fact. But sometimes asking these types of questions can lead to a better understanding of where future opportunities might be found— and the kind of unforgettable experiences that can fill a lifetime.

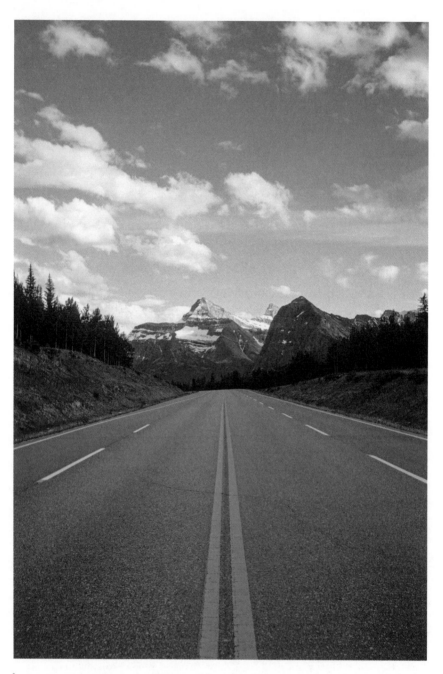

On the road, mountains ahead: Alberta, Canada.

CHAPTER TWENTY-FIVE
MEETING U.S. ATHLETES AT THE MONTREAL OLYMPICS

In 1976, when I was sixteen, I had just made my way by train from New York City to Montreal, Canada, for an American Youth Hostel bicycle trip in the Canadian Rockies. The group was planning to stay in Montreal for a day, then head by train to Jasper, Alberta.

The official start of the Olympic Games was just a few days away in Montreal. Since we were in the city, a few of us decided to go to the Olympic grounds in the early morning of July 12 to see if we could get inside and meet some athletes.

My first bright scheme—finding a hard hat to wear so I could walk through security—didn't work. So we moved on to the next plan. A few of us from the bicycle trip climbed into an ambulance with about six guys who were ambulance drivers. They allowed us to ride with them, and they seemed to enjoy having us along.

We got past security with no problem, but once we were inside the

Trans Canada train stop, after our ill-thought-out adventure.

275

security perimeter the drivers wouldn't let us out of the ambulance for fear of losing their jobs. So we drove back through the security checkpoint and piled out of the ambulance.

Our first two tactics having failed, our little group decided to try to climb some walls—only to be caught at the top. So we climbed back down.

We eventually came across an open doorway and went in. Almost immediately, we met a French kid who worked at the Olympics and didn't seem to mind that we were inside without a pass. He said he was supposed to be meeting some of the U.S. athletes and invited us to go with him. So we ended up meeting some runners in the 100- and 200-meter races after all.

All was going great until the whole lot of us were making our way back and got stopped by security and held for questioning until the boss showed up. The boss called for a police car to come and transfer us to the main police station at the stadium to be interrogated.

There were two police officers, and it was kind of like a good cop/bad cop situation, with one guy being somewhat nice and the other kind of tough. One of the kids in my group was carrying his bicycle pump with him (to prevent it from being stolen), so they took it apart and checked it. We thought that was a little weird, but this was the first Olympics since the 1972 Munich terrorist attack, which had ended in the deaths of eleven Israeli athletes and a West German police officer, so they obviously had to be careful.

We were interrogated three times and finally let go. The police officers said they would drive us and our bicycles to the train station, where we could meet up with the rest of the students and the leader of the American Youth Hostel trip.

The French kid, who was still with us, asked the detective driving us if we could at least see the track and field inside the stadium before we had to go. The detective agreed to bring us past there, and it was impressive. I still remember all the orange seats and the huge television screen at one end of the stadium.

When we got to the station, the leader of the trip was a bit surprised that we showed up in a police car! We had dinner with the French kid before getting on the train at 9:30 p.m., for our three-day ride to Jasper.

Kibbutz Ein HaMifratz ahead.

CHAPTER TWENTY-SIX
FROM KIBBUTZ POOL TO APARTMENT IN JERUSALEM TO HEBREW UNIVERSITY

It was 1980 in Northern Israel, and I was twenty, living at Kibbutz Ein HaMifratz. My friend Lisa was leaving the kibbutz the next day, and we were hanging at the pool on a typical July afternoon.

As Lisa lounged by the side of the pool, she asked me to swim over to her.

"Hey David, I've got an idea. My friend got an apartment in Jerusalem, starting late August, and I'm going to hang out with her then. Do you want to join us?"

"Sure, that sounds cool."

"OK, great. Let's plan to meet on the twenty-fourth of August."

"That works."

"How about meeting at the central bus station?"

"What time?"

"How about four in the afternoon?"

One month later, I was headed to the central bus station in Jerusalem, wondering if Lisa would actually be there, or if she even thought I would

be there. If she was there, would I find her? It's a fairly big station, but I figured that two people looking for each other couldn't be too difficult.

Sure enough, Lisa was there. And she couldn't believe that I was, too.

"I *told* you I'd be here," I said.

Lisa and I hung out in Jerusalem for a few days. At one point, another of Lisa's friends, Naomi Jacobs, came over to visit. As we talked, she suggested that I sign up for a one-year program at the Hebrew University. A few days later I went to the university, but instead of applying for the one-year program, I decided to apply as a regular full-time student.

Kibbutz Ein HaMifratz, near Akko, Israel, 1980.

Fellow kibbutzniks (from left) Jeff, Walter, and Andres at ulpan living quarters.

Cardboard factory where I worked at Ein HaMifratz—on return visit in 2011, before its replacement with automated system.

Hebrew University student Ginge and friend, 1980.

My friend Anat, Jerusalem, Israel 1980.

Beautiful place to study: Jerusalem, Israel.

My dorm at Hebrew University on Mount Scopas, revisited thirty years later.

I was accepted as a temporary resident of Israel. The university actually gave me a free dorm room and a stipend for food. I ended up attending school there for about a year and studied Jewish history.

It was fascinating to go to school on Mount Scopus. The campus was right next to the Mount of Olives, and you could pretty much look over the Old City of Jerusalem. You could see the Via Dolorosa, the spectacular walls of the Old City of Jerusalem, and the Temple on the Mount.

During that time, my friend Jozef had signed up to work as a waiter at the Jerusalem Sheraton, when the place was still being built, and he encouraged me to sign up too. I worked nights at the Jerusalem Sheraton for quite a while as a waiter, while going to school full-time. I made all of two dollars an hour, but it added up over time. I managed to save about $2,800, which, together with the proceeds from a guitar I sold, earned me about $3,000—money that I promptly used to take a trip through Asia, where further adventures awaited.

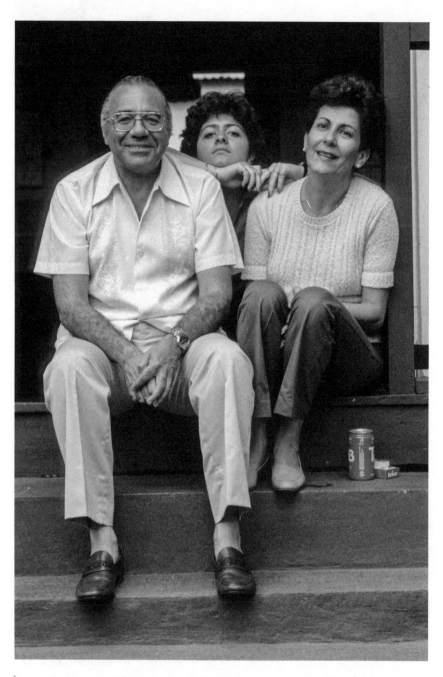

Friend Ana Maria Scarpetta (center) with her surgeon father, Rodrigo, and mother, Angela, at their finca, Colombia, 1983.

CHAPTER TWENTY-SEVEN
PHOTOGRAPHING SURGERY IN COLOMBIA

In was 1983, and I had just received a letter from a friend from Spain whom I'd met in Israel. I needed to get the letter translated, and what better solution than to ask a Spanish teacher at my old high school? When I approached the teacher, she said she was too busy but knew the perfect person to help. I followed her to a classroom, and there was Michelle Dugand, a visiting student from Colombia.

Michelle was very helpful. She was a joy to talk to. She had a captivating personality, and she was beautiful. We started hanging out and became good friends before she headed back to Colombia. I made plans to visit her in Barranquilla.

When I arrived in Colombia, Michelle brought me to a house where one of her friends was living. It was a house shared by five guys, mostly students. With Colombia being a Catholic country, it wouldn't have been proper to have a boy stay at a girl's house unless they were married.

Michelle visited me there, and we went to the beach often. She had planned an upcoming trip to Cali, in the south, through the Rotary Club and thought she could get me on the trip, so I signed up. Once in Cali, I looked up another friend, Ana Maria Scarpetta, whom I knew from the University of Massachusetts in Amherst, where I was attending college.

I searched the phonebook (an actual physical phone book) and found that there were twenty-three Scarpettas. I wrote down each number and decided to call each one until I found Ana Maria. I could get only three pesos in change from the reception desk, so I hoped to luck out.

I started by calling the residence of the only Scarpetta who was a doctor. I figured he must be educated, and likely connected, and could at least point me in the right direction. When someone answered, I said, "¿Ana Maria está?"

"Uno momento," was the response.

I was shocked—I had found her on the first call! She invited me for lunch and said she and her mom would pick me up at 12:30 p.m.

That night I was introduced to her dad, Rodrigo, and he asked me to join him for a drink. We talked a lot about his work at the hospital. The scene reminded me of my own dad, who was a dentist—how he would come home after a stressful day and have some bourbon to unwind.

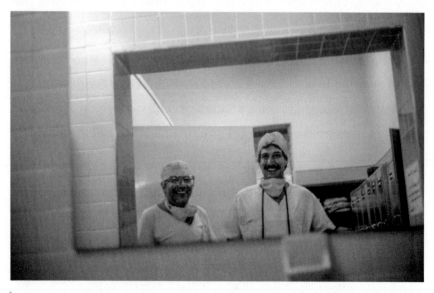

Suiting up with Dr. Rodrigo Scarpetta before surgery.

Ana Maria's father was the chief of surgery for two separate hospitals, and there was one type of surgery he performed differently than other doctors. In a case that would typically call for a colostomy, he would instead sew up the large intestine to itself. Dr. Scarpetta had done this procedure by accident back when he was an intern, at a time when the surgeon couldn't make it to the hospital quickly enough to treat a patient who had been stabbed.

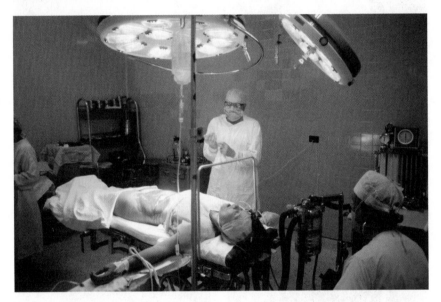

Surgery commences on woman with large-intestine tumor.

The medical team at the time thought the patient would get an infection—which a colostomy is designed to prevent—but he didn't, and he survived without further surgery.

After the event, Dr. Scarpetta came across stories of surgeons doing the same procedure during the Vietnam War, because of limited options on the battlefield. Years later, when he became chief of surgery, he researched the procedure further and started performing it on a regular basis. He had never lost a patient.

Dr. Scarpetta was scheduled to perform this procedure the following morning, and after hearing that I was an amateur photographer, he asked me if I wanted to photograph the surgery.

A picture of concentration.

Steady hand: Dr. Scarpetta at work.

Stitching up large intestine.

Later that night Ana Maria took me aside and told me that her dad had asked if I might want to stay in her younger brother's room, since he was away studying in the United States. She said it was an invitation her parents had never made before—again, in that Catholic country, it wasn't usual for parents of a young woman to ask a young man to stay in their home. Because I had a hotel room that was already paid for, I politely declined, but after that night I was at the Scarpettas' house practically every day, for breakfast, lunch, and dinner.

The next day, Ana Maria's mom dropped me off at the hospital to photograph Dr. Rodrigo Scarpetta in surgery. We washed our hands forever and got gowned up. When Dr. Scarpetta opened up the patient's belly, it was very hard to watch. I wondered if I'd be able to handle it.

I figured the next part would be worse, seeing the surgeon work with the intestines, but it was actually more abstract and easier to photograph. All in all, it was a very interesting experience, if one that convinced me I couldn't be a surgeon.

Closing incision after successful surgery.

In the coming days I spent a lot of time with Ana Maria and her friends, neighbors, and parents, which was really nice. Ana Maria's mother worked at the Museum of Modern Art in Cali, and she gave me a tour. The Scarpettas also took me to their *finca*, or "farmhouse," in the mountains.

On my way back to Barranquilla I had a stopover in Bogota, where I decided to make my way to the Museo del Oro before riding up the funicular—a kind of cable railway—to see a spectacular view of Bogota from Mount Monserrate.

As I've found in each place I've visited, there are so many encounters waiting if you're open to a bit of uncertainty, and have an interest in new experiences.

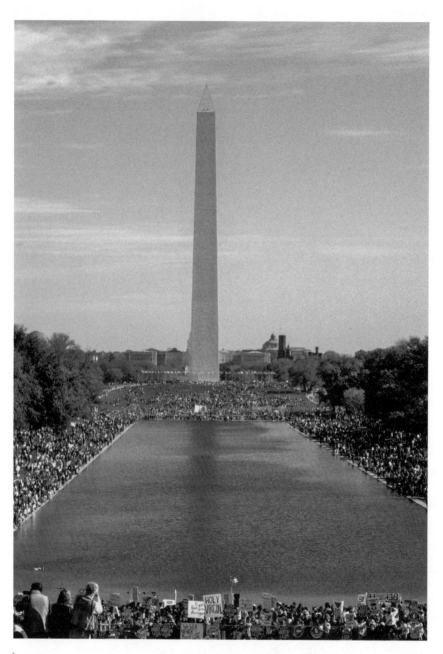

*National Organization for Women (NOW) rally at Lincoln
Memorial Reflecting Pool, Washington, DC, 1989.*

CHAPTER TWENTY-EIGHT
VIEW FROM THE LINCOLN MEMORIAL

In November of 1989, my mom, her friends, and their daughters were all planning to head down to Washington, DC, for a National Organization for Women (NOW) rally. I wanted to go too, but was hoping to document the event, not simply attend it, and wondered if I could get photo credentials to do so.

I made a phone call to the NOW office in Boston and asked about getting credentials. The person I spoke to said no, but she knew a person in DC who once worked in their office and suggested I try calling her. She told me the woman's name was Pam Hughes, and I thought, "Huh, that's interesting." I knew a young woman from my high school graduating class named Pam Hughes. I wondered if she could possibly be the same person, but figured it was unlikely.

I called down to DC and reached the Pam Hughes at the NOW office. I told her my name and said I was hoping to get credentials for the upcoming event. Pam asked what organization I was with, and when I told her I was a freelance photographer, she said, "Oh sorry, we don't have any credentials for freelance photographers."

"Oh, OK," I said. "By the way, did you once work in the Boston office? Are you from the Boston area?"

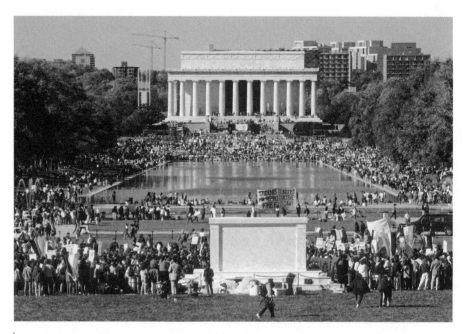

Impressive crowd: NOW rally amasses by Lincoln Memorial.

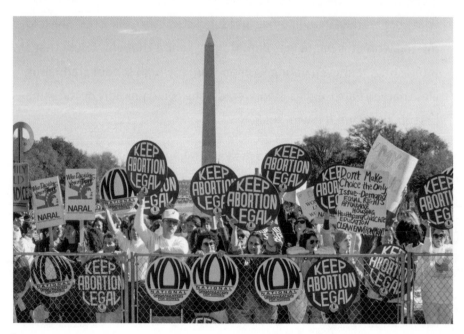

Signs of the times.

"Yes, I am," she said. "Oh wait, David, I remember you now, and your dad too. He was my dentist. I remember him fondly."

We talked a bit more, and in the middle of one of her sentences, Pam said, "Oh, by the way, you have your credentials—just ask for me when you get down to the rally, and I'll give them to you."

NOW participants represent their states.

On November 12, I met up with Pam in DC at the Lincoln Memorial, and she handed me the credentials. The passes allowed me to go up on the stage, where I was able to photograph Senator Dianne Feinstein and other well-known participants. At one point, while I was taking a photo of Peter Yarrow (from the '60s folk group Peter, Paul, and Mary), I started backing up and bumped into somebody. As I turned around to apologize, I realized it was Helen Reddy, singer of the anthemic '70s song "I Am Woman."

Making her voice heard.

A sea of supporters.

"Oh, I'm so sorry," I said—then asked if I could take her photo.

"Of course," she responded, and was so gracious.

Got it goin' on: singer Helen Reddy, NOW speaker. Ed Harris (left).

I noticed that photographers and TV crews were lining up to get permission from the National Park Service to ascend to the top of the Lincoln Memorial and photograph the crowd and surroundings from above. The woman in charge was telling people that only a few small groups would be allowed on the roof, due to regulations, and because the stairwell was very narrow.

One at a time, she asked people what news outlet they were with. The answers were to be expected: *New York Times, Washington Post, L.A. Times,* CNN. . . .

"Oh sorry," I heard her say. "You didn't get advance credentials." She was pretty dismissive, no doubt because she knew that CNN (albeit in its early

days) knew the drill. I thought, "Wow, she's saying no to CNN—that's not a good sign for me!"

Eventually it was my turn. "I'm a freelance photographer," I said, and quickly heard a "no freelancers" before she was on to the next person.

When the group had reached capacity, the woman told the rest of the folks to come back in forty-five minutes, when she would figure out the next group. While I was waiting, I talked with the Park Service woman a bit—just schmoozing and asking her questions about this and that, hoping she would take a liking to me or take me more seriously. She was very stern, but also a bit witty, so I thought, "Hmm, maybe I'll come back and try again."

I returned to the line, and my turn came again.

"Oh, are you still here?" she said.

"You gotta give a break to a freelance photographer," I said. "Just let one freelancer up there."

"You have a face only a mother could love." The idea that she was joking around, even at my expense, gave me hope.

"Lady, you can call me whatever you want, as long as you get me up on top of the Lincoln Memorial." She kind of laughed—but I didn't get on that group either.

I convinced myself that my chances were improving. Unfortunately, they had to skip a group, because the lights in the stairwell went out, and it was pitch black without them. Someone was working to see if it was possible to get people up there using flashlights.

Finally, the last chance was at hand. As my Park Service acquaintance was going through the people still waiting, she looked at me and hesitated.

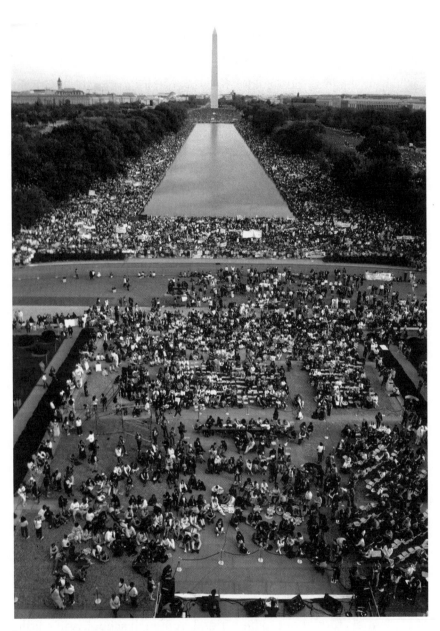

Worth the wait: from the roof of the Lincoln Memorial.

"You can go up," she said.

I couldn't believe it.

I walked with the group past Lincoln's statue toward the back, then up through some incredibly narrow stairwells, with the Park Service folks carrying flashlights. You wouldn't have been able to see a thing without those flashlights. When I got to the top, I was surprised to find that the roof was not made for walking on. It had clearly not been designed for people to be up there.

I started taking some standard photos looking straight down from the roof, and some aimed out at the sea of people gathered around the reflecting pool, all the way down to the Washington Monument. I walked around on the edges of the memorial, looking out over Washington, and took a photo of one of the bridges spanning the Potomac.

It was just spectacular. The Lincoln Memorial is my favorite of all the memorials and monuments in Washington, DC. To my mind, nothing comes close to how special it is, largely because of who Lincoln was, but also because of the breathtaking monument itself. There's no other monument that features such a magnificent figure—even the memorial to Thomas Jefferson, off the beaten track, is not as grand as Lincoln's. And, of course, George Washington's monument has the obelisk, but not a big statue. As a Western society, we don't normally believe in making a statesman into an icon, but Lincoln was one of our most revered presidents, and for good reason.

My initial phone call for permission, which would normally have been denied, turned into the luck of the draw when the very person in charge of credentials turned out to be a friend from high school. Add a little wit and some perseverance, and I somehow found myself on top of the Lincoln Memorial, where I took in a vision I will never forget.

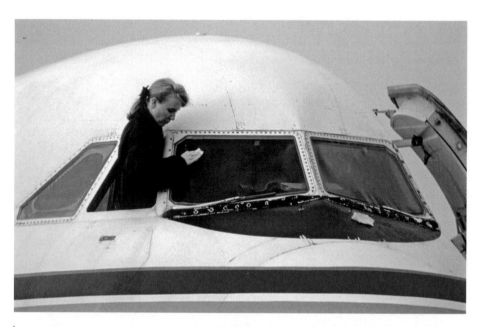

Cleaning windshield before takeoff, Guatemala City, 1993.

CHAPTER TWENTY-NINE
IN THE COCKPIT

In 1993, after landing a photography gig through the ministry of tourism in Malawi, I decided to set my sights on Central and South America. As with the African trip, I first sent a letter to each of the ministries of tourism throughout the South American continent. After some time had passed, an agreement was reached with INGUAT (Instituto Guatemalteco de Turismo, the Guatemalan Institute of Tourism) for me to photograph in that country in 1996.

I pointed out to INGUAT that their country was similar in size to Malawi, where I had spent a month photographing, and that I would need about the same amount of time to cover Guatemala. But they agreed to only two weeks. They insisted on developing some of my film while I was in Guatemala, which I agreed to (and in fact, once they'd developed and seen some of my images, they asked me to extend my photo project by another couple of weeks).

The guides who picked me up the next morning, Señorita Valentina Flores and Señor Reyes, had been mistakenly informed that I was from Italy, so they started speaking to me in Italian. I told them I was from the United States and didn't speak Italian, and they informed me that neither of *them* spoke English, save for a few words. This meant we had to speak to each other in Spanish, which actually ended up being a good thing—I knew only a limited amount of words, but was forced to improve my Spanish over the next two weeks.

I was scheduled to go to Tikal (the most famous archeological site in Guatemala), a location in the far northern part of the country that's almost always reached by air. Because I would be in Guatemala City the night before, INGUAT decided to have me take a few photos of the night-life around town. While the guides got a chance to be with their families, another person from INGUAT took me around, then brought me to the airport for an early flight around 5 a.m.

Passengers board Tikal Jets plane.

When we arrived at the airport, the guide made sure to get me situated with the government airline staff at the counter so they knew I was working for INGUAT before he left to return home. The staff gave me carte blanche to roam around as I liked. I asked if I could go out on the tarmac to get photos of the planes with the sun rising, then of the passengers boarding.

"Of course," they said. As I was taking photos from the tarmac, the pilot came down the stairs of the plane to see what I was doing and have a

nice chat. He was very relaxed and very nice, and he had a good sense of humor. I continued with my shots of the passengers boarding the plane and could see that the seats would probably be almost filled by the time I got onboard. The seats weren't assigned, so I figured I'd be in the back of the plane.

Another plane landing, La Aurora International Airport.

When I was almost finished taking the photos, the person in charge of airport operations came out to say hello and escort me onto the plane. As we entered, he asked, "Do you want to sit up here?" I looked around and saw that there were no seats available. Was he referring to the flight attendants' fold-down seats? That would be interesting.

The head of operations then proceeded to open the cockpit door and introduce me to the captain and first officer. "Yes, we've met," the captain said and asked the pilot if I could sit in the jump seat. "Of course!" was the response.

OK, *this* was something I totally wasn't expecting. One of those bells went off in my head, indicating that this would be one of those incredible times that becomes a once-in-a-lifetime experience. When I wrote all those letters to the ministries of tourism, I could not have foreseen what the effort might lead to.

I noticed that the first officer was a woman, which I thought was really cool. I'm not sure if I'd ever come across a woman pilot on a commercial jet before. Even now, twenty-five years later, I don't often see women in that position. In 2021, as I write this, the highest percentage of female pilots are in regional airlines, at 6.4 percent. Only 5 percent of pilots at major airlines are female.

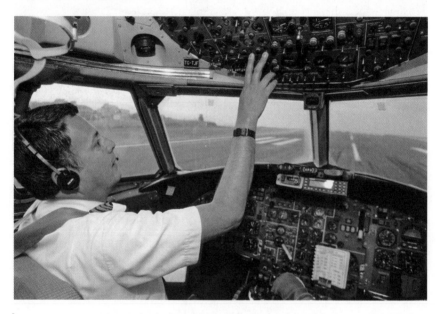

Captain prepares for takeoff, cockpit of BAC 111 401-AK.

I got situated in a seat that was centered between the captain and the first officer, but set back about three feet. I had my four-point harness buckled, and my cameras at the ready. As the pilots began performing their before-takeoff checklist, I found a bolt lying on the floor of the

cockpit. I waited until they'd finished their checklist before asking the captain, in my not so great Spanish, "Quizas qué necesites eso?" Meaning, "Maybe you need this?" I was joking with him, of course, pretending to ask if it might be important.

His response was equally in jest: "No, eso es parte de la cola," meaning, "No, that's just part of the tail."

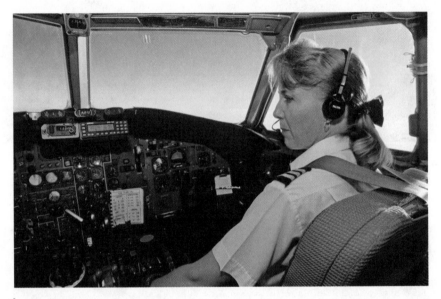

First officer checks controls.

Takeoff was an eye-opener. The front of the plane began bouncing up and down, as did our seats, since we were directly above the front wheels. Once we were airborne and heading north, away from the populated areas, I could see vast beautiful forests, as well as small areas that were being deforested. The pilot noted how bad the deforestation was, along with his feeling that the practice needed to be stopped. I was a bit surprised that he was an environmentalist, but it made sense when I thought about how often he flew over this area, taking in a bird's-eye view of the progressive destruction.

From the cockpit: mountains en route to Tikal.

Looking down on Petén landscape.

PULLING A WHALE

The small island town of Flores.

Landing at Flores.

The climb to the top.

Mayan temple pyramid, Yax Mutal, Tikal.

As we got closer to our destination, the captain asked me if I wanted to take photographs of Flores, the island near the airport. I said sure, thinking he'd just point out what side of the plane I should point my camera, or maybe tilt the plane a bit for me to get a good photo. Instead, he radioed to air traffic control and asked to do a fly around Flores before coming in for a landing. They gave him permission, so we did a 360 around the island, which made for a few nice shots.

When I was younger, a friend named Bob Lebewohl—my dad's patient and a former airline pilot—would do this kind of thing with me at the drop of a hat so I could take photographs. But in that case it was just Bob and me in the plane, a PT-17 Stearman biplane that had been used as a World War II trainer. This flight was different, as there were many dozens of passengers in the cabin behind us. Even though the diversion offered *them* a nice view of Flores too, it was a bit unusual to have a

commercial passenger jet deviate from its normal flight path just so I could take a few photos.

When I came out of the cockpit to deboard, I noticed that some passengers were looking at me, as if to say, "What was that all about? How did you get to sit with the pilots during the flight?" My answer would be (for this and so many of the experiences I was lucky enough to have had): right place, right time. Engage with people, express an interest you have, and someone might just point you in the right direction—or lead you to an opportunity you never imagined you could have.

CNN Hero Aki Ra (right), former child soldier, with deminer Yary.

CHAPTER THIRTY
RETRACING DITH PRAN'S STEPS IN SIEM REAP, CAMBODIA

It was 2010, and I had decided to travel to Cambodia. I'd be traveling with Titony (Tony) Dith, the eldest son of Dith Pran, who had worked with my uncle, the reporter Sydney Schanberg, during the war in Cambodia. Accompanying us would be Tony's uncle, Tan Ser.

My uncle Sydney, then a journalist for the *New York Times*, had written the longest *New York Times Magazine* article ever published (to that point) about his experiences with Dith Pran in Cambodia, as well as Pran's struggle for survival under the Khmer Rouge—a powerful piece that was later adapted into a film called *The Killing Fields*.

I had talked to Tony for a number of years about going to Cambodia. I had never been there, and he hadn't been back since 1975, at the end of the war. When the United States decided to pull out of Cambodia, Pran's family was evacuated from Cambodia, leaving Pran behind to work with Sydney. Because they arrived late to the landing zone they were put on that last helicopter, joining the U.S. ambassador.

Pran had served as Sydney's "fixer": translating, obtaining valuable information from locals and soldiers, and securing passage to places that were almost impossible to get to. He was known to the press as the best freelance fixer covering the war, and Sydney, realizing just how valuable Pran was, had asked the *New York Times* to hire him full-time.

When the Khmer Rouge took over the Cambodian capital in 1975, Pran and Sydney both risked their lives to stay behind and cover the evolving story for the *New York Times*.

At one point during the takeover, Sydney and Pran went to a hospital to assess casualties and talk to people about what was happening just outside the city. As they were leaving the hospital, they were taken captive by Khmer Rouge soldiers.

With Sydney already inside the armored vehicle, Pran began arguing with the soldiers, and Sydney thought at first that Pran was protesting getting inside. Speaking in French to disguise the fact that he was an American, Sydney asked the driver why Pran was arguing, fearing that the soldiers would kill Pran right there. The driver, who had himself been captured and forced to drive the vehicle, told Sydney that the soldiers actually wanted Pran to leave, because they were looking only for foreigners, and that Pran was arguing to get *in*.

Pran knew the soldiers were likely to kill Sydney, and that he needed to go with him, because Sydney didn't speak Khmer. Pran knew that in doing so he was likely signing his own death sentence.

The soldiers let Pran get into the vehicle, then drove him and the other captives to a river bank. Pran, who was a master at reading situations and people, knew who was in charge, even though they weren't wearing chevrons or other insignias on their uniforms.

Pran approached one man and was relentless, telling him that Sydney was there to report the story of the Khmer Rouge success. He made a huge gamble: he told this man that on the radio, which had been taken over by the Khmer Rouge, he'd heard it announced that foreigners should not be harmed. The soldier knew if he disobeyed his superiors he'd be killed, so Sydney and Pran were released.

Sydney and Pran sought out the French embassy, where they were able to take refuge for a few days. Eventually the Khmer Rouge realized it wouldn't be good for them to kill the foreign journalists who stayed behind because they represented many countries, and this would hurt the regime in the long run. So they sent the foreigners, including my uncle Sydney, by truck to the Thai border. Pran, unable to join them, snuck out of the embassy, beginning a harrowing four-year odyssey.

In addition to Pran, there were other family members who did not make it out of Cambodia before the Khmer Rouge took over. Tan Ser was one of them. He and Pran had lived together for much of their time under the repressive and murderous regime, doing forced labor.

In 2010, when Tony and I were making plans to travel back to Cambodia, Tan called to ask if he could come with us. I wasn't fully on board with the idea at first. But after a few hours of talking to Tan, hearing about the chronic nightmares he endured while living under the Khmer Rouge, and learning that he wanted to bring us to places where he had lived with Pran, I was enthused about having him travel with us. I had wanted to do some retracing of the storyline of Sydney and Pran, and though Tony had not been a part of that, Tan had been there.

The trip immediately became much more interesting. Tan brought us to one place where he and Pran had lived, down a very long road that led to a small village. Tan was shocked to see that the place hadn't changed in thirty-five years. The villagers were socializing next to their huts, with cows grazing in the background. The bicycles from Phnom Penh (the main mode of transportation) and the clothing were much the same as when Tan had been there in the '70s. We saw a lot of red circular marks on the villagers: evidence of cupping, a form of Chinese medicine.

Tan showed us the plot of land where the house he lived in with Pran had been, and he told us how similar their house was to those next to it that were still standing. He pointed out where the tree was where Pran had been tied up and was almost beaten to death for stealing a handful of rice.

A few of the locals began talking to us, and one man said to Tan, "I know you." Tan still recognized him, thirty-five years later. It was as though time had stood still all those years—yet Tan was now an architect in Washington, DC, the lead architect for the renovation of the Pentagon and other prominent government buildings.

Tan's sister (Tony's mother), Ser Meoun, had organized much of our time with family there. When we arrived, the first place we visited was the gravesite of their ancestors. It was the custom to do so, no matter what time you arrived. We happened to arrive late at night, yet Meoun had arranged for the local monks to be there, and they performed a very involved ceremony. I loved this idea of honoring those who came before you, and making it your first priority.

At the relatives' home there was a demining truck that one of the family members drove. I asked if I could get in contact with the deminers, thinking I might be able to photograph in the mine fields.

I was put on the phone with a man named Bill Morse who ran the land-mine museum, and I told him I was a friend of the family. I asked if I could possibly photograph the deminers doing their work, but Bill said no. He explained that they didn't do that for anybody, not even VIPs who contacted them. He suggested that I come visit the museum.

About four or five days later, after visiting Preah Ang Thom Pagoda, we went to one of the huts along the river to eat lunch. A relative of Tan's

was wearing Khmer Rouge clothing, with a headband and all, and he didn't say much. He seemed a bit hardcore.

There was some discussion in the hut about a man named Aki Ra who was a deminer scheduled to be featured on TV as a CNN Hero. I used to watch the CNN Heroes program every year at Thanksgiving and knew how cool that was. I asked someone if we could call Aki Ra, and Tan and I both spoke to him. Aki Ra said we could interview him the following night.

A little while later, Aki Ra called back and said that he couldn't do the interview after all, because he was heading to a site to do some demining. He said he could meet us instead on the highway, on his way northwest from Siem Reap. I was sad that we wouldn't have time to interview him, but at least we'd have the chance to meet him.

Meeting Aki Ra (center), with (from left) deminers Phoeut, Yary, Kohichi. Ban; Dith Pran's brother in law Tan and sister Meoun; Rain and Yon.

Riding with Aki Ra in back of truck, headed toward border of Thailand.

When Tan, Tony, Meoun, and I met Aki Ra and his group on the side of the road, we took photos and made introductions. The deminers were all dressed in military clothing. At one point, Meoun came up to me to say that Aki Ra wanted to know if I would like to go . . . and before she could finish her sentence, I interrupted her to say yes. Aki Ra had invited me to go with them! We would return the following evening.

Moeng Yary shows her demining patch.

Meoun wouldn't let her eldest son, Tony, come with us, because she was a bit worried about the whole thing. But her brother Tan wanted to go, and she said OK because I didn't speak Khmer.

Tan and I jumped into the bed of a pickup truck with Aki Ra and another deminer. We had on only T-shirts and shorts. But I had my cameras, which was the most important part! The drive was about three or four hours toward the Thai border, during which we couldn't talk because of the wind.

We arrived that night and stayed in a very stark guest house, but it was better than sleeping on the ground. Normally the deminers would have slept out on the fields near their camp, but they were worried that Tan and I might get malaria from the mosquitos.

Headed to the demining site.

The next morning, we went to the landmine field camp and met the other deminers working there. We ate, then had a briefing, which I photographed since I didn't understand what they were saying. I was told

the hospital had requested the area around the building to be demined, since they wanted to expand the hospital grounds. During the war, the hospital had been used as a compound by the military, so landmines had been laid around it to keep the enemy away.

Aki Ra coordinates via radio.

After the briefing, we suited up in demining gear and headed to the demining area. I interviewed Aki Ra for quite a while and took photos and video the rest of the time.

That afternoon, as we were heading back, we stopped at the radio head-quarters of Pol Pot (Saloth Sâr), the notorious leader of the Khmer Rouge regime. It was a location where Aki Ra had once removed landmines. The people in this area were definitely Khmer Rouge.

There was a charge to go into the place, and we said fine. We checked out the installation inside and found it interesting, with the original maps painted on the walls and large open rooms where military leaders once talked strategy.

With a deminer equipped with metal detector.

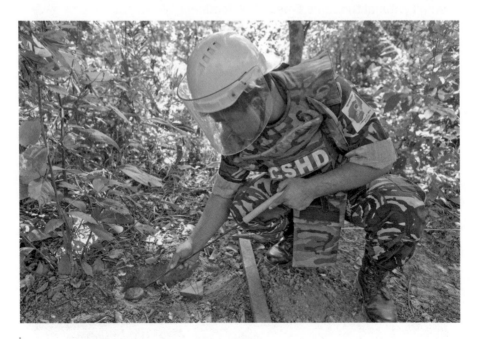

Aki Ra begins removal of Chinese landmine.

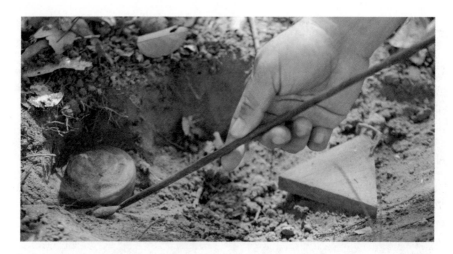

Handling with care.

After leaving, we headed to the landmine museum. Aki Ra suggested that we not tell Bill Morse we had been with him in the landmine fields. When Tan and I were dropped off, we waited down the street a bit so we didn't enter at the same time as the deminers. We met Bill, and he gave us a tour, during which he told us about Aki Ra, which was a bit awkward.

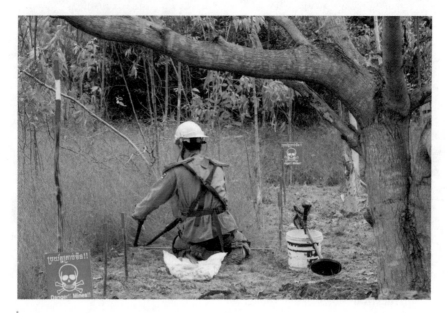

Skilled worker in landmine field.

A year later, Bill came to the United States and found out that we had been with Aki Ra in the landmine field after all. Fortunately, Bill liked the video I had made, because it not only showed what the deminers did, but also included Aki Ra telling his life story, making it a useful resource for Bill's talks at the museum. He ended up asking me to come back and do some more filming. So in 2015, I returned to Cambodia, this time with my friend Ruben Rassi, to film again in the landmine fields.

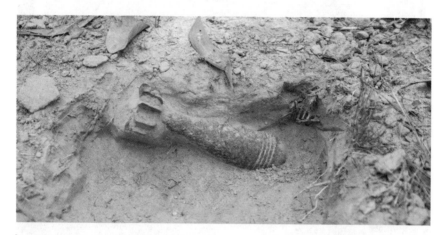

Mortar shell ready for removal after thirty-plus years in the ground.

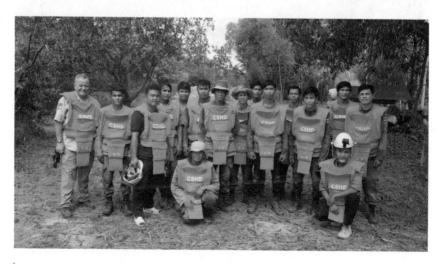

Bill Morse (at left) with Aki Ra and deminers.

On our visit to the Land Mine Museum and Relief Facility.

Bill Morse, director of the museum, during our visit.

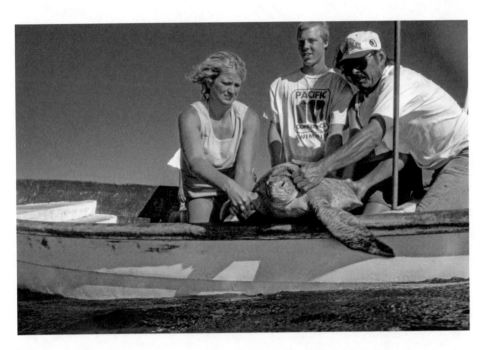

Earthwatch volunteers (from left) Stephanie Gregory, Nikolai (Niko) Gurda, and assistant Yoshio Suzuki release black sea turtle, Baja, 1997.

CHAPTER THIRTY-ONE

ADDENDUM: NIKOLAI GURDA WRITES ABOUT HIS MANTA RAY EXPERIENCE

Nikolai was a seventeen-year-old volunteer when I met him on an Earthwatch project in 1997. Here he describes his unexpected adventure.

A warm wind blew off the Baja desert as we pushed off in our small inflatable boat at sunrise. We motored across the calm bay toward the nets we had left the night before in hope of safely catching black sea turtles for the migration study we were conducting. When we arrived at the spot we knew to be right, there was no sign of the dozen or so white buoys that marked the length of the net. We circled the area for several minutes, and just before we were about to give up the search, Jeff Seminoff, the lead scientist, saw a white shadow about six feet below the surface of the water. He dove in and struggled to pull the buoy back up to the boat, and I started bringing up the hundreds of square meters of wet net hand over hand. We hadn't been pulling long when I glanced behind the boat and realized that we had a strong wake behind us, and the engine was off. Jeff theorized what might be at the other end: a sea lion, a dolphin, or a hammerhead shark, all of which were common in those waters.

I stood in the knee-deep pile of net, lost in the rhythm of pulling, when a fin broke the surface to our right, then another to the left, and then the

massive body wrapped in net came into focus. It was a giant manta ray, at least fifteen feet across and bigger than our boat. My mind reeled as I tried to make sense of what I was seeing. It wouldn't have been more surreal if a mermaid had been at the other end of that net. Jeff, on the other hand, was already making a plan.

"We need scuba gear, masks, and knives," he shouted as he started the engine and told me to dump the net overboard. We raced back to camp, grabbed the gear we needed, and were back as fast as our boat would carry us. I started hauling the net back up as Jeff prepped his scuba gear and splashed in just as the captive animal came back into view.

It was almost as if the manta ray knew that we were there to help. It didn't dive or fight as Jeff approached; it slowly pumped its wings and glided just below the surface while it was being touched by the first

human hands of its life. Jeff cut away net one-handed with his dive knife as quickly and carefully as he could while holding onto the animal so he wouldn't be left behind. With both feet planted against the front of the boat, I fought to hold that net until my arms and legs shook. Jeff climbed out to give me a break and then asked if I wanted to take a turn. Despite the dire situation we were in trying to save this animal, I grinned from ear to ear and said, "Hell, yes."

Principal investigator Jeff Seminoff works to untangle manta ray from netting.

Manta ray freed: Nikolai finishes the job.

I threw on my mask, snorkel, and fins, grabbed the knife, and began crawling up the net toward the ray. Its skin was as rough as sandpaper, and I could feel the powerful muscles undulating beneath my body as I crawled over its back and started cutting away the net. I knew that it was a filter feeder, and there were no teeth to worry about, but panic still froze me for an instant as my left hand slipped into its mouth and I touched the smooth, slimy fibers inside. I cut net for a long time, and finally, all that was left was the one bundle still connecting us to Jeff and the boat. Jeff yelled to cut it free and let go, but I was a seventeen-year-old boy who felt about as invincible as it was possible to feel in that moment. I did cut it free, but I didn't let go. Without the drag of the boat to hold it back, the manta ray surged forward, and I held on tight as I scrambled to pull the remaining strands from around its mouth and head. Then it dove and flipped. Despite the obvious danger, I arrogantly held on and had a glimpse of the boat's silhouette as we swam beneath it. We surfaced behind the boat, and after a moment of calm, I let go. Within seconds

this massive, mysterious animal returned to its deep, dark world, and Jeff and I were left quietly floating in calm water in the morning sun.

What made such a potent experience possible? Twenty-four years ago, as a junior in high school, I wrote an essay that won me a scholarship to join a sea turtle research project in Baja, Mexico. I had never been on a plane, never left the country, and never traveled alone. Every moment of that experience was transformative, from setting foot in my first airport to falling asleep to the sound of whales breathing across the dark water to eventually to helping save a giant manta ray's life. It was a large step in the direction of who I was to become and the first step in a calling I still feel to experience as much of the world as deeply as I am able.

I've been an elementary teacher in public schools for the last fifteen years, and a year has not gone by that I don't tell my students the story of the manta ray. That story, and many others like it over the years, are not just exciting to tell. Each of those experiences, each of those stories, is a part of who I am and how I see the world. The power of seeking opportunity—and saying yes when it presents itself—is that you are choosing to take an active hand in the creation of yourself. When the author of this book, David Barron, emailed me a few months ago, it was because the fire in my seventeen-year-old eyes as I told my story stuck with him twenty-four years later. I know his book illustrates that power of experience and inspires you to go out and find the stories that will become as much a part of you as your bones.

HOW DO YOU FIND AN OPPORTUNITY?

Researching and networking are a lot easier now than they were thirty-plus years ago, when I mailed out letters to all the ministries of tourism in Africa, then waited months, and sometimes years, before finding a response in my mailbox. If you're interested in seeking out memorable travel or life experiences, not only do you have the internet at your disposal, but every activity or conversation you engage in has the potential to open a door to something new. A few random possibilities:

- Look for events or meetings in your community on subjects that interest you, and talk to experts or other participants about your goals.

- Network with your friends or through social media and make it known what kind of experiences you'd like to participate in.

- Check in with your teachers or professors to see if they have any research projects planned in the field, for a summer or longer, and ask if they could use an assistant.

- Take inventory of your skills—whether in mechanics, teaching, nursing, cooking, writing, video, photography, building, or driving a bus—and do some research on what kind of projects or travel adventures could use them. You may be surprised—for example, some teaching opportunities in unusual places don't require a teaching degree.

- Consider scouting for a temp job in a place you'd like to travel to. When I was in Port Lockroy, Antarctica, I met some people who were working a three- or six-month stint there.

- If you have an idea formulated but don't think you can afford to pursue it, use the internet or ask a librarian to help you look for a grant or funding resources. The work you put into those applications could really pay off.

Below is just a small handful of the programs out there looking for volunteers or participants at the time of this writing. While some involve a cost, others, such as the Peace Corps or AmeriCorps, offer a stipend, housing, and even education awards. Keep in mind that website addresses change frequently, but a quick Google search should link you to the information you need.

- **The Peace Corps.** In more than 140 countries, volunteers work side by side with local leaders on projects encompassing agriculture, the environment, health, education, and more. peacecorps.gov

- **AmeriCorps.** Across the United States, members and volunteers work with more than two thousand nonprofit organizations. americorps.gov

- **Earthwatch.** This nonprofit, which I was involved with as a photographer for sixteen years, connects laypeople with scientists worldwide to do environmental research. Volunteers pay a fee to participate and don't need experience—they're trained onsite. earthwatch.org

- **US Park Service.** At national parks across the country, volunteers share their skills, talents, and enthusiasm in support of these beautiful spaces. nps.gov/getinvolved/volunteer.htm

- **U.S. Fish and Wildlife Service.** Lead tours, rescue turtles, restore habitat, and more as a volunteer for national wildlife refuges across the country. fws.gov/volunteers/

- **Wildlands Studies.** Students get experience working in the field through programs at wildland sites in the United States and abroad. wildlandsstudies.com/all-field-programs

- **InterExchange.** Want to work in another country and immerse yourself in its culture? Teaching English, becoming an au pair, and other opportunities are available in eleven countries. inter-exchange.org/work-travel/

- **Workaway.** Another work-travel program, billed as "the leading community for cultural exchange, working [vacations], and volunteering in 170 countries." www.workaway.info

- **Fund for Education Abroad.** Drawn to studying abroad, but find it's beyond your means? This organization's mission is to provide scholarships and ongoing support to students who are under-represented among the U.S. study abroad population. https://fundforeducationabroad.org

ACKNOWLEDGMENTS

To Jane Elizabeth Jakuc, for sending me "the sign" to write the book. I wear the shirt, I wrote the book. Thank you!

To Teri Keough, for making my wandering writings stay in their lane. You are so good at what you do.

To Marie Richardson, Tamara Enz, and Lisa Owider, for your endless feedback.

To Sue Cuyler, for helping me make sense of the design.

To Nicky Decesare, for helping with InDesign and turning me on to Mascot Books. Ocho!

To my cousin Rebecca Schanberg, for your illuminating suggestions and helping me streamline the manuscript. For the love you share.

To Ruben Rassi, who, on short order, came up with a brilliant cover design. An incredible soul and friend.

To the people of Barrow (Utqiaġvik) who introduced me to a different way of life. And to their ancestors who lived off this land long before the modern world arrived.

To Earthwatch, and all the researchers who invited me into their worlds, whose infectious enthusiasm was a bright light to those around them.

To all those who facilitated putting me in the right places at the right times.

ABOUT THE AUTHOR

David Barron is a freelance photographer who has worked for private schools, colleges, and nonprofits in the Boston area since 1987. Between shoots, he frequently travels to photograph wildlife and wondrous places. David's early travels with his sister and parents were instrumental in sparking wanderlust, and his first trip through Asia, taken after he lived in Israel for an extended time, inspired his long-held belief that the world is boundless, full of places to see and opportunities to fulfill. This has led David to weave a path through many countries on seven continents, all the while taking photographs that document his journeys. *Pulling a Whale* presents a selection of colorful stories from David's travels that illustrate how "opportunity and serendipity" can lead to amazing experiences—stories he hopes will inspire readers to pursue adventures of their own.